ART

Auguste Rodin

ART

Conversations with Paul Gsell

Translated by Jacques de Caso
& Patricia B. Sanders

Introduction by Jacques de Caso

University of California Press

Berkeley Los Angeles London

Originally published as *L'Art: Entretiens Réunis par Paul Gsell* (Paris: Bernard Grasset, Éditeur, 1911).

University of California Press
Berkeley and Los Angeles, California
University of California Press, Ltd.
London, England
© 1984 by the Regents of the
University of California
Printed in the United States of America

1 2 3 4 5 6 7 8 9

LIBRARY OF CONGRESS CATALOGING
IN PUBLICATION DATA

Rodin, Auguste, 1840–1917.
Art: conversations with Paul Gsell.
(Quantum books)
Translation of: L'Art.
Bibliography: p.
Includes index.
1. Art—Addresses, essays, lectures.
2. Artists—Addresses, essays, lectures. I. Gsell,
Paul, 1870–1947. II. Title.
N7445.R57 1984 700 78-65464
ISBN 0-520-03819-3

Contents

Illustrations

Acknowledgments

We would like to thank Mme. Monique Laurent, director of the Musée Rodin in Paris, for allowing us access to the documents concerning Paul Gsell kept at the museum and published here. We also thank the family and friends of Paul Gsell for having looked—unfortunately in vain—for traces of the collaboration of Gsell and Rodin, and we thank M. Beausire, archivist of the Musée Rodin, for having directed the same inquiry at the Maison Grasset.

Introduction

Few artists' written accounts on art have had such sustained success as the one published in 1911 by Auguste Rodin and Paul Gsell. The number of editions and translations appearing immediately after the original publication and continuing to the present is eloquent testimony.

This translation is the second in the English language. In preparing it, we established two objectives. The first was to offer a translation closer to the text than the first, closer to what we recognize, or in some places believe, to have been the thought of the authors. This we wanted to accomplish to the extent allowed by a text that the authors intended at times to be poetic, imaged, and evocative and whose meaning in numerous cases remains difficult to pin down. Our second objective was to minimize the florid expressions popular in critical prose at the beginning of the twentieth century and preserved in the 1912 translation. These verbal formulas suited the taste of the Symbolist generation, but today this language and its desired effects seem outmoded. At times it conceals rather than reveals the authors' ideas.

The great success of *Art* since its appearance in 1911 is easily explained. It reflects the immense international popularity of Rodin, who after 1900 was showered with honors by nearly everyone. Its success is also linked to the ambitious program the title announces, one that several contemporaries denounced, however, as a sign of conceit, even arrogance, in Rodin.[1]

His name and reputation at the time this book appeared have caused most people to overlook the circumstances of its preparation and the role played by his co-author, Paul Gsell, in the enterprise.[2] These are not negligible considerations,

attached as they are to the most ambitious and important of
Rodin's writings, whether published or signed by him alone
or produced in collaboration. This broad question of Rodin's
collaborations still remains confusing, as does his persistent
attraction to verbal expression.[3] In the case of *Art*, the roles
played by the two authors in the conception, economy, and
writing of the text cannot be measured with precision.
Notes, drafts, and proofs cannot be found in the Rodin or
Gsell archives or in the records of the publisher, Maison
Grasset. In fact, *Art* had already appeared in print by the time
of its publication as a book in 1911. With only slight varia-
tions in style, the book republished a series of articles co-
signed by Rodin and Gsell and issued the preceding year, in
a different order but with the same titles, in a Parisian journal,
La Revue (formerly *La Revue des Revues*).[4] Paul Gsell was an
assiduous contributor to this periodical after 1900. The col-
lection of articles that compose the book were in a way pre-
faced by two earlier articles on Rodin, signed by Gsell, that
appeared in 1906 and 1907 and that were not kept in the
book.[5]

 The historical records show little about Paul Gsell himself.
He was born in 1870 and died in 1947. His relationship with
Rodin seems to have been limited to their collaboration on
Art. Son of the painter Caspar Gsell, belonging to a Protes-
tant family, he was at the time he met Rodin quite aware of
what was happening in the artistic and literary scene. He
wrote a book on art in museums; he published some "inter-
views" with Anatole France[6] that prefigure the formula he
used with Rodin—a rather common formula in journals
around the turn of the century.[7] Between 1904 and 1908, he
also published in *La Revue* several articles on art.[8] His ideas
on painting are in a way superficial and not very remarkable;
he denounces, for instance, the success of Cézanne, Gau-
guin, and Van Gogh as the result of the speculation of the art
market.[9] Overall, his ideas are in harmony with *La Revue*'s
relatively advanced ideological positions on intellectual and

political issues. Gsell's ideas, though presented clearly, do not stand out from those of other critics who claim for art above all a social and civic function, a theme repeated often around 1900. Nevertheless, his ideas took a much more emphatic political and polemical turn when he later wrote theater criticism, an area where his contribution has been noticed. He discovered the Soviet Union's theater and Stanislawski, and he wrote three important books.[10] At the same time, he occupied an administrative position as librarian for the city of Paris.[11]

The Gsell-Rodin relationship is documented at the end of the year 1903. Gsell wrote to Rodin to get his opinions for publication, along with those of others in *La Revue*, on the question of "whether patriotism is incompatible with humanitarian sentiments that are developing today in the civilized world." Gsell wrote out Rodin's declaration.[12] The following year, in a review of the Salon de la Société Nationale, Gsell published ideas expressed to him by Rodin. In May 1906 and in November 1907 he wrote two articles on Rodin in which he revealed the sculptor's ideas. These two articles touched on some ideas later taken up in the series of articles published in 1910 in *La Revue*. Some opinions, however, were not kept in the series of articles or in the book, particularly those on the contemporary painters Albert Besnard, Charles Cottet, Van Gogh, and Cézanne; other opinions, such as those on Jules Dalou, were used verbatim in *Art*.[13]

One imagines that the relationship between Gsell and Rodin during the year 1910 was sustained. We know that at least in one instance Gsell helped Rodin with his correspondence.[14] Their contact between the publication of the book and the declaration of war in 1914, however, seems to have been more sporadic. After the publication of *Art*, *La Revue* published a last article signed by Rodin and Gsell that the publisher identified as an addendum to the book;[15] as in the 1910 series of articles, Rodin's signature is printed first in capital letters. Gsell's interest in Rodin did not vanish: he

wrote several more articles on Rodin, two long ones in the special issue of *L'Art et les Artistes* that the publisher and critic Armand Dayot dedicated to Rodin in 1914.[16] There he developed several ideas already found in the two articles *La Revue* of 1906 and 1907. On the death of Rodin, Gsell wrote an obituary and some contributions of less importance.[17] For instance, on the eve of publishing his "interviews" with Anatole France in book form, he published a version of an episode found in *Art*, an encounter between Rodin and Anatole France.[18]

The scant documentation (a few letters and telegrams) reveals little about the precise nature of the collaboration between Rodin and Gsell. However, in one note to Rodin, Gsell refers to "his" (Gsell's) chapter on busts that appeared in *Art*. In another instance, he made an allusion to a chapter in progress titled "Decorative Art," the substance of which, perhaps, was not kept in the series of articles or in the book. On another occasion, he informed Rodin that he continued working on "our book." All this provides little insight.[19] So we must assume for the time being that the collaboration was like that Rodin had with others, the sculptor communicating his thoughts orally or in writing. Throughout his life Rodin filled numerous notebooks with such thoughts; occasionally he let people publish excerpts as aphorisms. Then followed a text written by someone else and, it seems, carefully corrected and annotated by Rodin to produce the final version.[20]

Today the book by Rodin and Gsell remains a rich source of observations, judgments, and ideas that it is not our purpose here to analyze. The content is well known. The book is the indispensable basis for all who have written about Rodin up to the present time, whether they analyze his works or discuss the foundations of his aesthetics—his theory of artistic expression, his ideas on Nature, his attraction to expression in art, his conception of movement in art, his interpretation of ancient art, his ideas on modernity, women, and the social purpose that he ultimately assigned to

art. Besides recording Rodin's judgments on works of art—his own and all those of others—and providing direct information on Rodin, his ideas, and his techniques, this long Socratic dialogue suggests and develops a wealth of ways of feeling, thinking, and seeing that make it a fundamental work of reflection on art at the turn of the century. Although the book is deeply embedded in the major intellectual themes of the time—Symbolist spiritualism, Bergsonism, the neoclassicism of the last decades of the nineteenth century—except for historians of sculpture, those who write the history of art and thought around 1900 still often neglect the work. The broad study that will illuminate all aspects of this book remains to be written, and it promises to be a difficult one to write. We hope that someone will undertake this task. The aims of such a study, among others, would be to seek the sources of the ideas of Rodin and Gsell and, of course, to evaluate their originality.

Translators' Note

Our aim in this translation of the Rodin-Gsell dialogues—
the first since the Romilly Fedden translation in 1912—is to
present an English text as clear and understandable as possi-
ble to the modern reader. While endeavoring to retain the
essence of the original, we have occasionally simplified the
convoluted and complex sentences that characterized the
critical discourse of the period. Yet we have retained the cap-
italization of abstract terms such as Nature and Art (fre-
quently but not consistently capitalized); this style may give
a certain antique flavor to the essays, but it also preserves the
role of capitals as indicators of emphasis and metaphysical
tone. Where words have more than one meaning, or have no
exact equivalent in English (as in the case of *la conscience* or *la
pensée*), the original French follows in brackets.

ART

Preface

A group of picturesque buildings crowns a hill above the hamlet of Val-Fleury near Meudon. They so delight the eye that you suspect they belong to an artist.

Here, as a matter of fact, Auguste Rodin has established his residence.

He lives in a Louis XIII pavilion of red brick and ashlar with a steeply gabled roof.

To one side is a large rotunda with a columned portico in front. This housed a private exhibition of his works in 1900; at that time it was located next to the Pont de l'Alma. Since he liked it, he had it rebuilt in this new location where he uses it as a studio.[1]

A little further on, at the edge of the back slope of the hill, one sees an eighteenth-century château, or rather just a façade, and a beautiful porch with a triangular pediment framing a forged iron grille.

These various buildings emerge from an idyllic orchard.

The site is certainly one of the most enchanting in the environs of Paris. Nature shaped it very pleasantly, and the sculptor, who has established himself here, has been embellishing it to his taste for more than twenty years.[2]

Last year, at the end of a bright day in May, as I walked with Auguste Rodin under the trees that shade his charming hill, I confided to him my desire to write, at his dictation, his remarks on art. He smiled.

"You are a strange duck!" he said to me. "You are still interested in art. This is hardly a concern of our time.

"Today artists and those who admire them are regarded as fossils. Imagine a magathere or a diplodocus wandering the streets of Paris. This must be the impression that we produce on our contemporaries.

"Our age is one of engineers and manufacturers, not artists.

"In modern life, utility is what people want. We are forced to improve existence materially. Every day science invents new means of feeding, dressing, or transporting men. It manufactures bad products economically to give dubious pleasures to the greatest number. It is true that it also brings real improvements to satisfy all our needs.

"But the spirit, thinking, dreaming are no longer issues. Art is dead.

"Art is contemplation. It is the delight of the mind that penetrates nature and divines the spirit by which nature itself is animated. It is the joy of intelligence that sees clearly into the universe and creates the universe anew by endowing it with consciousness. Art is the most sublime mission of man since it is the exertion of the mind trying to understand the world and to make the world understood.

"But today, humanity believes it can do without Art. It does not want to meditate, contemplate, dream. It wants to enjoy itself physically. It is indifferent to lofty and profound truths: it merely appeases its corporeal appetites. Mankind at present is bestial: it has no use for artists.

"Art is also taste. It is the reflection of the artist's heart in all the objects he makes. It is the smile of the human soul visible in the home and in its furnishings. It is the charm of thought and sentiment made part of everything that serves mankind. But how many are there among our contemporaries who feel the need of lodging and furnishing with taste? Formerly, in the France of old, art was everywhere. The lowest middle-class persons, even the peasants, used only objects that were beautiful to behold. Their chairs, their tables, their pots, their pitchers were handsome. Today art is being driven

from daily life. People say what is useful need not be beautiful. Everything is ugly, everything is manufactured hastily and without grace by stupid machines. The artist is the enemy.

"Ah! My dear Gsell, you want to record the musings of an artist. Let me look at you: you are a truly extraordinary man!"

"I realize," I told him, "that art is the least concern of our time. But I hope that this book will be a protest against the ideas of today. I hope that your voice will arouse our contemporaries and make them understand the crime of allowing the best part of our national heritage, the boundless love of Art and Beauty, to be lost."

"May the gods hear you!" said Rodin.

* * *

We skirt the rotunda that serves as a studio. In the peristyle are sheltered many ancient objects: a small partly clad vestal faces a grave orator draped in a toga, and not far from these a cupid tyrannically rides a sea monster. In the midst of these figures, two Corinthian columns of charming grace raise their shafts of pink marble. This assemblage of precious fragments reveals the devotion of my host to Greece and Rome.[3]

Beside a deep pond drowse two beautiful swans. As we pass, they uncoil their long necks and hiss angrily. Their savage behavior provokes me to say that this type of bird lacks intelligence.

"They have intelligent lines and that is enough!" replies Rodin, smiling.

Here and there one sees in the shade small cylindrical marble altars ornamented with garlands and bucrania. Under a trellis covered by a sophora, a young headless Mithra immolates a sacred bull. At an intersection an Eros sleeps on a lion skin: sleep has tamed the one who tames wild beasts.

"Don't you think," Rodin says to me, "that greenery is the

most appropriate setting for ancient sculpture? Wouldn't you say that this drowsy little Eros is the god of this garden? His plump flesh is cousin to this diaphanous and luxuriant foliage. The Greek artists loved nature so much that their works bathe in nature as if they were in their element."

Let us take note of this attitude. Usually statues are placed in a garden to embellish the garden; for Rodin, statues are placed here in order to be embellished by the garden. This is because, for him, Nature is always the sovereign mistress and infinite perfection.

A Greek amphora of pink clay lies on the ground, leaning against a box-tree. It has probably spent centuries at the bottom of the sea, for it is encrusted with charming madreporic vegetation. It seems to have been abandoned there, and yet it could not be presented more gracefully, for naturalness is supreme taste.

Further on, one sees a pretty torso of Venus. The breasts are hidden by a handkerchief tied behind the back. Unwillingly, one thinks of some Tartuffe who out of modesty believes he ought to cover those charms which are too tempting:

> By such objects souls are wounded
> And this causes guilty thoughts. . . .[4]

But surely my host has nothing in common with the protégé of Orgon. He himself informs me what his idea had been: "I tied this cloth over the breast of this statue," he tells me, "because this part is less beautiful than the rest."

Then, unbolting a door, he has me pass onto the terrace where he had erected the eighteenth-century façade of which I have spoken.

Close up, this noble architecture is imposing. It is a majestic portico raised on eight steps. In the pediment supported by columns is sculpted a Themis surrounded by Amors.

"In the past," my host tells me, "this beautiful château

stood on the slope of a nearby hill at Issy. Often I admired it in passing. But the land merchants bought it and demolished it."

At this moment fury flashes in his eyes.

"You cannot imagine," he continues, "what horror seized me when I saw this crime being committed. To tear down this dazzling building! It had the same effect on me as seeing the scoundrels disembowel a beautiful virgin before me!"

A beautiful virgin! Rodin pronounces these words with a tone of profound piety. One senses that the white, firm body of a young girl is for him the masterpiece of creation, the marvel of marvels!

He continues: "I asked these sacrilegious persons not to disperse the materials but to sell them to me. They agreed. I had all the stones moved here in order to reassemble them somehow or other. Unfortunately, as you see, I have only reconstructed one wall."

In fact, in his desire to acquire a vivid, artistic delight without delay, Rodin did not follow the usual logical method, that is, of raising all the parts of the building at the same time. At present he has only reassembled one side of his château, and when one goes to look through the railing of the entrance, one sees only the beaten earth on which some aligned stones indicate the plan of the building to be reconstructed. This is a château for the eye . . . a château for the artist!

"Truly," murmurs my host, "these old architects were proud men! Especially when one compares them with their unworthy successors of today!"

Having said this, he draws me to a point on the terrace from which the stone profile seems to him the most beautiful.

"How harmoniously this silhouette stands against the silvery sky," he says, "and how boldly it dominates the pretty valley hollowed below us."

Rodin is deep in ecstasy. His loving gaze envelops both monument and landscape.

From the elevated spot where we stand, our eyes take in an

immense expanse. In the distance, the Seine, where rows of tall poplars are mirrored, traces a great silver loop as it flows toward the robust Sèvres bridge. . . . Further on is the white bell-tower of Saint-Cloud set against a verdant hill. There are the bluish heights of Suresnes. There is Mont Valérien, which is blurred by a dreamy mist.

To the right, Paris, the gigantic Paris, unfolds its innumerable houses to the horizon. Houses so small in the distance, it seems they could be held in the palm of your hand. Paris, monstrous and sublime vision, colossal crucible where pleasures, pains, drives, feverish dreams of the ideal boil incessantly and chaotically.

1

Realism in Art

At the end of the long rue de l'Université, very near the Champ-de-Mars, in a true corner of that deserted and monastic province, is the Dépôt des Marbres.

In a vast courtyard overgrown with grass repose heavy grayish blocks, showing in spots fresh breaks of a frosty white. These are the marbles that the state holds in reserve for the sculptors it honors with its commissions.

On one side of this courtyard there is a row of some ten studios that have been granted to various sculptors. This is a little artistic community, marvelously calm, which resembles a beguine convent of a new type.

Rodin occupies two of these cells. One shelters his *Gates of Hell*, which is cast in plaster and is striking in its incomplete state.[1] He works in the other one.

More than once, I have visited him here in the evening when he was finishing his day of noble labor. Taking a chair, I would watch him at work and wait for the moment when night would force him to stop. The desire to take advantage of the last light of day would make him work feverishly.

I see him again, kneading the clay into small, quick sketches. This is a game that delights Rodin during his recesses from the more patient care he gives to the large figures. These sketches, made in an instant, excite him because they allow him to seize, in motion, beautiful gestures whose fugitive truth would escape a more thorough but slower study.

His working method is unique.

In his studio several nude models, men and women, move around or rest.

Rodin pays them to provide him constantly with the images of nudes, moving with all the freedom of life. He contemplates them constantly, and this is how he has familiarized himself, for a long time, with the sight of muscles in movement. The nude—an exceptional revelation for modern people and generally an apparition lasting for the posing session only, even for sculptors—has become for Rodin a customary sight. The ancient Greeks acquired a routine knowledge of the human body by contemplating the exercises in the palestra: disc throwing, boxing, wrestling, and the foot races. This knowledge allowed Greek artists to speak naturally the language of the nude. The author of *The Thinker* is assured of this language himself by the continual presence of undressed human beings passing before his eyes. This method has enabled him to decipher the expression of feelings in all parts of the body.

Generally the face alone is considered to be the mirror of the soul; the mobility of the features of the face seems to us the unique exteriorization of the spiritual life. In reality, there is not one muscle of the body that does not express variations within. Each speaks joy or sadness, enthusiasm or despair, calm or rage. Outstretched arms, an unrestrained torso can smile with as much sweetness as eyes or lips. But in order to be able to interpret all aspects of the flesh, one must be trained patiently in the spelling and reading of the pages of this beautiful book. This is what the ancient masters did, aided by the customs of their civilization. This is what Rodin has done anew in our time by the strength of his will.

His eyes follow his models. He savors silently the beauty of the life that plays in them. He admires the provocative suppleness of a young woman who bends to pick up a boaster; the delicate grace of another who stretches her arms, raising her golden hair above her head; the nervous vigor of a

man who walks. When a model offers a movement that
pleases him, he asks that the pose be held. Then quickly, he
takes the clay . . . and a sketch is soon ready. Next, just as
quickly, he goes on to make another sketch in the same way.

One evening, when night had begun to cast soft shadows
in the studio and while the models were dressing behind
some folding screens, I talked with the master about his ar-
tistic method.

"What surprises me about you," I told him, "is that you
behave quite differently from your colleagues. I know many
of them, and I have seen them at work. They have the model
get up on the pedestal (called the *table*) and ask him to take
such and such a pose. In most cases, they even bend or extend
the model's arms and legs to their taste; they incline or
straighten the torso and the head according to their desire,
just as if the model were an articulated mannequin. Then,
they go to work.

"You, on the other hand, wait until your models strike an
interesting stance before you reproduce it. Consequently,
the models seem to give orders to you rather than you giving
orders to them."

Rodin, who was wrapping his figurines with wet cloths,
answered softly: "I do not take orders from them but rather
from Nature.

"My colleagues, no doubt, have their reasons for working
as you have said they do. But in so violating Nature and in
treating human creatures like dolls, they risk producing ar-
tificial and lifeless works.

"As for me, as a seeker of truth and an observer of life, I
avoid imitating their example. I take from life the move-
ments I observe, but I do not impose movements on the
models.

"Even when my subject compels me to solicit from the
model a given attitude, I indicate this to him but carefully
avoid touching him to place him in this pose since I want to
represent only what reality offers me spontaneously.

"In everything, I obey Nature, and never do I dare give orders to it. My only ambition is servile fidelity to it."

"However," I said with some mischief, "it is not at all Nature, just as it is, that you evoke in your works."

Abruptly, he stopped manipulating the wet wrappings: "Yes, indeed, just as it is!" he responded, knitting his brows.

"You are obliged to change it . . ."

"In no way! I would curse myself for doing that!"

"But in the end, the proof that you change it is that a cast from life would not give the same impression as your work at all."

He reflected briefly and said: "That's true, for a life cast is less *true* than my sculpture. This is because it would be impossible for a model to hold a lively pose for the time it would take to made a mold. On the other hand, I conserve in my memory the totality of the pose, and I incessantly ask the model to conform himself to my memory.

"There is more to it.

"The life cast reproduces only the exterior whereas I reproduce the spirit, which is certainly also a part of Nature as well.

"I see the entire truth, not only what is on the surface.

"I accentuate the lines that best express the spiritual state that I interpret."

Saying this, he showed me, on a turntable near me, one of his most beautiful statues, a kneeling youth who raises his supplicating arms to the sky.[2] All his being is protracted by anguish. The body is thrown back. The thorax swells, the neck is strained with despair, and the hands seem to be projected toward some mysterious being they would like to grasp.

"Look!" Rodin told me, "I have accentuated the swelling of the muscles that express distress. Here, here, there—I have exaggerated the distance between the tendons that reveal the outburst of prayer."

And with a gesture, he underlined the most nervous parts of his work.

"I have caught you, master!" I said ironically. "You yourself say that you have stressed, accentuated, exaggerated. You see then that you have changed Nature."

He laughed at my obstinacy.

"Oh no!" he responded. "I have not changed it. Or, rather, if I did, I did it without being aware of it at the time. My feeling influenced my vision and showed me Nature just as I have copied it.

"If I had wanted to modify or beautify what I saw, I would have produced nothing good."

A moment later, he continued: "I concede that the artist does not perceive Nature as it appears to the common man since the artist's emotions make him aware of the inner truths that lie beneath appearances.

"But still, the only principle in art is to copy what one sees. This would not please the 'dealers in aesthetics,' but any other method is fatal. There is no recipe for embellishing Nature.

"It is only a question of *seeing*.

"Oh, no doubt, a mediocre man will never make a work of art by copying; this is because, in effect, he will look without *seeing*. In spite of noting each detail minutely, the result will be flat and without character. But the profession of the artist is not for the mediocre, and even the best advice could not give them talent.

"The artist, on the contrary, *sees*; that is to say, that his eye, grafted to his heart, reads deeply in the bosom of Nature.

"This is why the artist should trust only his eyes."

2

For the Artist Everything in Nature Is Beautiful

Another day, while standing next to Rodin in his large studio at Meudon, I looked at a cast of the statuette, so "magnificent in its ugliness," that was inspired by the poem of Villon on the beautiful helmet-maker's woman.

The courtesan, who was once radiant with youth and grace, is now repellent with decrepitude. She is as ashamed of her hideousness as she was once proud of her charm.

> Ah, cruel, arrogant old age
> Why have you beaten me down so soon?
> What holds me back from striking myself
> From killing myself with a blow?[1]

The sculptor has followed the poet step by step.

His old ribald, more shriveled than a mummy, laments her physical decline.

Bent double, crouching [à croupetons], her gaze runs desperately over her breasts, lamentable empty pouches; over her shockingly wrinkled belly; over her arms and legs, more gnarled than vine-stocks:

> When I think alas of the happy times
> What I was, what I've become
> When I look at myself naked

And see how I've changed so much
Poor, dried-up, lean and bony
I nearly go off my head.

"What's become of the smooth forehead
The yellow hair. . . .

"The delicate little shoulders
. .
The small breasts, the full buttocks

High, broad, perfectly built
For holding the jousts of love

This is what human beauty comes to
The arms short, the hands shriveled
The shoulders all hunched up
The breasts? Shrunk in again
The buttocks gone the way of the tits
. . . As for the thighs
They aren't thighs now but sticks
Speckled all over like sausages.[2]

The sculptor is not at all inferior to the poet. On the contrary, his work, with the fear it inspires, is perhaps even more expressive than the earthy verses of master Villon. The skin falls like flaccid cloth on the visible skeleton. The hooplike ribs of the carcass are accentuated under the parchment that covers it. And all this trembles, shakes, dries up, shrivels.

And from this spectacle, at once grotesque and heart-rending, comes a great sadness.

For what you see is the infinite distress of a poor, simple soul enamored with youth and eternal beauty, witnessing powerlessly the ignominious decline of her physical envelope. This is the contrast between the spiritual being which

claims endless joy and the body which goes away, dissolves, ceases to exist. Reality wastes away and the flesh agonizes, but dream and desire are immortal.

This is what Rodin wanted us to understand.

And I know of no other artist who has ever evoked old age with such ferocious coarseness.

But there is one! At the Baptistry in Florence, one sees at the altar a strange statue by Donatello: an old woman, who, if not entirely nude, is draped only in her long, stringy, filthy hair that clings to her ruined body. This is Saint Magdalene withdrawn to the desert. Heavy with years, she offers to God the cruel macerations to which she has submitted her body, in order to punish it for the damnable care she once lavished on it.

The ferocious sincerity of the Florentine master is such that Rodin's assuredly does not surpass it. And yet the sentiment of the two works is different. Whereas Saint Magdalene, because of her desire for renunciation, seems more radiant in her joy as she sees herself become more repugnant, the old helmet-maker's woman is terrified to find herself so like a cadaver.

Modern sculpture, then, is much more tragic than sculpture of the past.

Having for some moments contemplated in silence the marvelous "model of horror" before my eyes, I said to my host: "Master, no one admires this striking figure more than I, but I hope you will not be angry if I inform you about the effect it produces on many visitors, especially women, to the Musée du Luxembourg."[3]

"I would be grateful if you would tell me."

"Well, in general the public turns away from it exclaiming, 'Ugh! How ugly.'

"And I have often noticed women covering their eyes with their hands to shield themselves from this vision."

Rodin began to laugh heartily.

"My work," he said, "must be eloquent to provoke such

vivid impressions, and, no doubt, these people fear philo-
sophical truths that are too crude.

"But I am concerned only with the opinion of people of
taste, and I am delighted to have received their approbation
of my *Helmet-Maker's Woman*. I am like that Roman singer
who answered the hooting crowd: '*Equitibus cano!*' ('I only
sing for the upper classes!'), that is to say, for the connois-
seurs.

"The common man would like to believe that what he
judges ugly in reality is not material for the artist. He would
like to prohibit us from representing what displeases and of-
fends him in Nature.

"This is a grave mistake on his part.

"What one commonly calls 'ugly' in Nature can become
great beauty in art.

"In the realm of real things, one calls 'ugly' that which is
deformed; that which is unhealthy; that which suggests the
idea of illness, of debility, and of suffering; that which is con-
trary to regularity, the sign and condition of health and
strength. A hunchback is 'ugly.' A bow-legged person is
'ugly.' A poor person in rags is 'ugly.'

" 'Ugly' also is the soul and conduct of the immoral man,
the vicious and criminal man, the abnormal man who harms
society; 'ugly' is the soul of the parricide, the traitor, ambi-
tious people without scruples.

"And legitimately, creatures and objects from which one
expects only evil are called by an odious epithet.

"But when a great artist or a great writer gets hold of one
of these types of 'ugliness,' he instantly transfigures it. With
a wave of his magic wand, he transforms it into beauty; this
is alchemy, this is like a fairy tale.

"When Velázquez paints Sebastian, the dwarf who be-
longed to Philip IV, he gives him such a moving look that we
immediately read in it the painful secret of this ill-favored
man. In order to assure his existence, he was forced to alienate
his human dignity, to become a plaything, a living bauble.

And the more poignant the martyrdom of the psyche lodged in this monstrous body, the more beautiful is the work of the artist.

"When François Millet represents a poor rustic catching his breath for a moment while leaning on the handle of his hoe—a miserable man broken by exhaustion, baked by the sun, as sodden as a beast of burden overcome by blows—he has only to accentuate in the expression of this damned soul his resignation to the punishment ordained by Destiny for this nightmarish creature to become a magnificent symbol of Humanity as a whole.

"When Baudelaire describes filthy, viscous carrion eaten by worms and imagines his adored mistress in this hideous way, nothing equals in splendor this terrible opposition of the Beauty, which one wishes were eternal, and the atrocious disintegration, which actually awaits it:

> And yet you will be like this dung,
> This horrible putrefaction
> Star of my eyes, Sun of my Nature,
> Oh my angel and my passion!
>
> Yes, such you will be, oh queen of the Graces
> After the last sacraments,
> When you pass beneath the grass and the lush flowers
> Rotting among the bones. . . .
>
> Then, oh my Beauty, tell the vermin
> Who will cover you with kisses
> That I have preserved the form and the divine essence
> Of my decomposed loves![4]

"And in the same way when Shakespeare portrays Iago or Richard III, when Racine portrays Nero or Narcissus, moral ugliness interpreted by such clear and penetrating minds becomes a marvelous theme of Beauty.

"The reason is that in Art, beauty exists only in that which has 'character.'

" 'Character' is the intense truth of any natural spectacle, beautiful or ugly. Character can even be called a 'dual truth'; for it is internal truth translated by the external truth. 'Character' is the soul, the feeling, the idea expressed by the features of a face, the gestures and actions of a human being, the colors of a sky, the line of a horizon.

"Now for the great artist, everything in Nature has 'character,' for the uncompromising frankness of his observation penetrates the hidden meaning of everything.

"And what is considered 'ugly' in Nature often presents more 'character' than what is called beautiful because in the contortion of a sickly physiognomy, in the scoring of a vicious mask, in every deformity, in every blemish the inner truth bursts forth more easily than from regular and wholesome features.

"And since it is solely the power of 'character' that creates beauty in Art, it often happens that the one who is the most ugly in Nature is the most beautiful in Art.

"There is nothing 'ugly' in Art except that which is without 'character,' that is to say, that which offers neither outer nor inner truth.

"The ugly in Art is that which is false; that which is artificial; that which seeks to be pretty or beautiful, instead of being expressive; that which is affected and precious; that which smiles without motive; that which is pretentious without reason; the person who throws out his chest and swaggers without cause; all that is without soul and truth; all that is only a parade of beauty and grace; all that lies.

"When an artist, intending to embellish Nature, intensifies the green of spring, the pink of dawn, or the red of young lips, he creates ugliness because he lies.

"When he tones down the grimace of pain, the deterioration of old age, the hideousness of perversity; when he organizes Nature, softens it, disguises it, tempers it to please

the ignorant public; he creates ugliness because he is afraid of
the truth.

"For an artist worthy of the name, everything is beautiful
in Nature because his eyes, boldly accepting every external
truth, read in Nature without effort, as from an open book,
every internal truth.

"He has only to look at a human face to decipher a soul; no
feature fools him. Hypocrisy is for him as transparent as sin-
cerity. The slope of a forehead, the slightest knitting of the
brows, a fleeting look reveal to him the secrets of the heart.

"He scrutinizes the spirit enfolded in the animal. He per-
ceives in glances and gestures the entire, simple inner life of
the beast—half-formed feelings and thoughts, hidden intel-
ligence, rudimentary tenderness.

"He is likewise the confidant of inanimate Nature. Trees,
plants speak to him like friends.

"The gnarled, old oaks tell him of their good will toward
humanity, whom they protect with their spreading
branches.

"Flowers converse with him through the gracious bend of
their stems, the lilting hues of their petals. Each corolla in the
grass is an affectionate word addressed to him by Nature.

"For the artist, life is an endless pleasure, a perpetual rap-
ture, a wild intoxication.

"Not that he sees everything as good since suffering so
often attacks those he cherishes, even himself, cruelly refut-
ing such optimism.

"But for him everything is beautiful because he walks
ceaselessly in the light of spiritual truth.

"Yes, even in suffering, even in the death of loved ones,
and even in the betrayal of a friend, the great artist—by
whom I mean the poet, as well as the painter or the sculptor—
finds the tragic pleasure of admiration.

"Sometimes his heart is tortured, but even more strongly
than the suffering, he feels the bitter joy of understanding
and expressing. In everything that he sees, he seizes clearly

the intentions of destiny. He regards his own anguish, his worst wounds with the enthusiasm of a man who divines the decrees of fate. Deceived by someone dear, he staggers from the blow. Then, steadying himself, he contemplates the perfidious one as a beautiful example of baseness. He greets ingratitude as an experience that enriches his soul. His ecstasy is sometimes terrifying, but this is still happiness because it is the continual adoration of truth.

"When he perceives people who destroy one another, youth that fades, vigor that flags, genius that burns out, when he sees face-to-face the will that decrees all these somber laws, more than ever he enjoys knowing, and, satiated with truth, he is formidably happy."

3

Modeling

One evening I had come to visit Rodin in his studio, and night fell very quickly as we talked.

"Have you ever looked at an ancient statue by lamplight?" my host suddenly asked me.

"Upon my word, no!" I said with some surprise.

"I astonish you, and you seem to consider the idea of studying sculpture, other than by daylight, a bizarre fantasy.

"Certainly natural light allows us to admire best a beautiful work in its entirety. But, wait a little! I want you to witness a sort of experiment that will no doubt be instructive to you."

While he was talking, he had lit a lamp.

He took it and led me to a marble torso standing on a base in the corner of the studio.

It was a charming little ancient copy of the Medici Venus. Rodin kept it there to stimulate his own inspiration while he worked.

"Come close!" he said to me.

He lit the belly with a raking light, holding the lamp to the side of the statue and as close as possible.

"What do you notice?" he asked.

At the first glance, I was extraordinarily struck by what was suddenly revealed to me. Indeed, the light directed in this way made me perceive quantities of slight projections and depressions on the surface of the marble that I never would have suspected were there.

I said as much to Rodin.

"Good!" he approved. "Look carefully!"

So saying, he very carefully turned the movable platform that held the Venus.

As it revolved, I continued to note lots of imperceptible projections within the general form of the belly. What at first glance had seemed simple was in reality something of unequaled complexity.

I confided my observations to the master sculptor.

He nodded his head, smiling.

"Isn't it marvelous?" he said. "Admit that you did not expect to discover so many details. Look! Look at the infinite undulations of the valley between the belly and the thigh. Relish all the voluptuous curvatures of the hip. And now, there, in the back, all those adorable dimples."

He spoke softly with a devout ardour. He bent toward this marble as if he were in love with it.

"This is real flesh!" he said.

Beaming, he added: "It must have been moulded by kisses and caresses!"

Then, suddenly, placing his hand flat on the statue's hip: "One almost expects, when feeling this torso, to find it warm."

Some moments later: "So, now what do you think about the usual opinion of Greek art?

"People say—it is the Academic School especially that has spread this opinion—that the Ancients, because of their cult of the ideal, scorned the flesh as vulgar and low and that they refused to reproduce in their works the thousand details of material reality.

"It is claimed that they wanted to give lessons to Nature by creating with simplified forms an abstract Beauty that addressed only the intellect and did not consent to gratify the senses.

"And those who speak this language justify themselves by the example that they imagine is found in ancient art. So they correct, castrate Nature, reducing it to dry cold contours, whose very regularity has little to do with reality.

"You have just seen how mistaken they are.

"No doubt, the Greeks, with their powerfully logical minds, accented instinctively the essential. They stressed the dominant features of the human type. Nonetheless, they never suppressed the living detail. They were content to subsume it and blend it into the whole. Since they were fond of calm rhythms, they involuntarily softened the less important prominences that might disturb the serenity of a movement, but they took care not to efface them entirely.

"Never did they make lying a method.

"Full of respect and love for Nature, they always represented it as they saw it. And on every occasion they fervently bore witness to their adoration of the flesh. For it is folly to believe that they disdained it. With no other people has the beauty of the human body aroused a more sensual tenderness. An ecstatic delight seems to hover over all the forms they modeled.

"This explains the incredible difference that separates the false academic ideal from Greek art.

"Whereas for the Ancients the generalization of the lines is a totalization, the sum of all the details, academic simplification is impoverishment, an empty puffing up.

"Whereas life animates and warms the palpitating muscles of Greek statues, the inconsistent dolls of academic art seem frozen by death."

Rodin was silent for a while, then: "I will confide in you a great secret.

"Do you know what causes the impression of real life that we have just felt with this Venus?

"It is the 'science of modeling.'

"These words seem trite to you, but you will realize their full importance.

"The 'science of modeling' was taught to me by a man named Constant, who used to work in a studio that produced decorative arts and where I began as a sculptor.

"One day, while watching me model in clay a capital or-

namented with foliage, he told me: 'Rodin, you are not doing the right thing. You make all your leaves flat. This is why they do not look real. Make some of them project toward you so that they seem to have depth.'

"I followed his advice and marveled at the results I obtained.

" 'Do remember what I am going to tell you,' Constant continued. 'From now on when you sculpt, never think of forms as planes, but always as volumes. Consider a surface only as a protruding volume—as a tip, however wide, pointing at you. This is how you will acquire the "science of modeling." '

"For me this principle was amazingly fruitful.

"I applied it to the execution of figures. Instead of imagining the various parts of the body as more or less flat surfaces, I represented them as projections of interior volumes. I endeavored to express in each swelling of the torso or the limbs the presence of a muscle or a bone that continued deep beneath the skin.

"And so the trueness of my figures, instead of being superficial, appeared to grow from the inside outward, as in life itself.

"Consequently I have discovered that the Ancients practiced precisely this method of modeling. And it is certainly to this technique that their works owe both their vigor and their quivering suppleness."

Rodin contemplated again his exquisite Greek Venus. And suddenly he said: "In your opinion, Gsell, is color a quality of painting or of sculpture?"

"Of painting, naturally."

"Very well, then, look at this statue."

Saying this, he raised the lamp as high as he could to light the antique torso from above.

"See these strong lights on the breasts, these energetic shadows on the folds of the flesh. Then look at these light shades, these half-lights, vaporous and trembling, on the

most delicate parts of this divine body, the transitions that seem so finely shaded that they seem to dissolve in the air. What do you say? Isn't this a prodigious symphony in black and white?"

I had to agree.

"As paradoxical as this seems, the greatest sculptors are as much colorists as the best painters or, rather, the best print-makers.

"They play so skillfully all the possibilities of relief, they combine so well the boldness of light and the modesty of shadow, that their sculptures are as luscious as the most chatoyant etchings.

"Now color—this is the comment I was coming to—is like the flower of beautiful modeling. These two qualities always go together, and they are what give all masterpieces of sculpture the radiance of living flesh."

4

Movement in Art

At the Musée du Luxembourg, there are two statues by Rodin which especially attract and captivate me: *The Age of Bronze* and the *Saint John the Baptist*. They are even more lifelike than the others, if this is possible. The works by the same author that keep them company in this gallery are all assuredly quivering with truth. They all give the impression of real flesh. All of them breathe, but these two move.

One day in the master's studio at Meudon, I told him about my predilection for these two figures.

"They can, in fact, be counted among those in which I have accentuated movement [*mimique*] most," he told me, "I have, however, created others in which the animation is not less striking: my *Burghers of Calais*, my *Balzac*, my *Walking Man*, for example.

"And even in those of my works where action is less stressed, I have always sought to include some indication of gesture; it is very rare that I have represented complete repose. I have always tried to express interior feelings through the mobility of the muscles.

"Even in my busts I have often given some inclination, some deviation, some expressive direction in order to enhance the meaning of the physiognomy.

"Art does not exist without life. When a sculptor wants to interpret joy, pain, any passion, he cannot move us unless he first knows how to make his figures come to life. For what is the joy or pain of an inert object, a block of stone to us? Now the illusion of life is obtained in our art by good modeling

and by movement. These two qualities are like the blood and breath of all beautiful works.''

"Master," I said to him, "since you spoke to me about modeling, I have noticed that I appreciate the masterpieces of sculpture more. I would like to question you about movement, which, I feel, has no less importance.

"When I look at your figure of *The Age of Bronze*, who seems to wake up, fill his lungs with air and raise his arms, or your *Saint John the Baptist*, who seems about to leave his pedestal to carry his words of faith everywhere, my admiration is mixed with astonishment. It seems to me that there is a little sorcery in this science of making the bronze move. I have, furthermore, often examined other masterpieces by your glorious predecessors—for instance, the *Maréchal Ney* and *La Marseillaise* by Rude, *The Dance* by Carpeaux, the wild beasts of Barye—and I confess I have never found an entirely satisfactory explanation for the effect that these sculptures produce on me. I still ask myself how masses of bronze or stone really seem to move, how evidently immobile figures appear to act and even engage in very violent efforts.''

"Since you take me for a sorcerer," Rodin responded, "I will try to honor my reputation by performing a task that is much more difficult for me than animating bronze: explaining how I do it.

"First, note that *movement is the transition from one attitude to another*.

"This simple statement, which sounds like a truism, is indeed the key to the mystery.

"You have certainly read in Ovid how Daphne is transformed into a laurel and Procne into a swallow. The charming writer shows the body of the one being covered with bark and leaves, and the limbs of the other being clothed with feathers, so that in each case one still sees the woman that will soon cease to be and the sapling or bird that she will become. You remember how in Dante's *Inferno* a serpent is glued to the body of a damned man and is converted into a man, while

the man is changed into a reptile. The great poet describes this scene so ingeniously that in each of the two beings, one follows the struggle of two natures, which progressively invade and supplant one another.

"It is basically a metamorphosis of this kind that the painter or sculptor executes in making his personages move. He makes visible the passage of one pose into the other; he indicates how imperceptibly the first glides into the second. In his work, one still detects a part of what was while one discovers in part what will be.

"An example will clarify it for you better.

"You have just cited Rude's *Maréchal Ney*. Do you remember this figure well enough?"

"Yes," I told him. "The hero raises his sword, and at the top of his voice he cries, 'Forward!' to his troops."

"That's right! Now, next time you pass this statue look at it even more carefully.

"Then you will notice that the marshal's legs and the hand that holds the sheath of the sabre are placed in the position they had at the moment he drew his sword. So the left leg is pulled aside so that the weapon is offered more easily to the right hand, which has just drawn it. The left hand is still in the air as if it still presented the sheath.

"Now, consider the torso. It would have been slightly leaning to the left at the moment when the gesture I have described took place. But the torso we see is erect, the chest thrown out. And his head turns toward the soldiers as he roars the order to attack. Finally, the right arm is raised and brandishes the sabre.

"So, you have here indeed a verification of what I told you: the movement of this statue is but the metamorphosis of a first attitude—when the marshal drew his sword—into another attitude—when he rushes toward the enemy, his arm raised.

"There you have the whole secret of gestures interpreted by art. The sculptor obliges, so to speak, the spectator to

follow the development of an act through one figure. In the example we have chosen, your eyes are forced to rise from the legs to the raised arm. Since, in the course your eyes follow, they encounter the different parts of the statue representing successive moments, they seem to see the movement actually enacted."

In the great hall where we were standing, there were precisely those casts of *The Age of Bronze* and of *Saint John the Baptist*. Rodin invited me to look at them.

Immediately, I realized the truth of his words.

I noticed that in the first of these works the movement appeared to mount upward as in the statue of Ney. The legs of this adolescent who is not completely awake are still soft and almost vacillating. But as the glance moves upward, one sees the attitude grow stronger: the ribs lift under the skin, the thorax dialates, the face is directed toward the sky, and the two arms stretch to shake off their torpor.

So the subject of this sculpture is the passage from somnolence to the vigor of being ready to act. Moreover, the slow gesture of awakening appears more majestic as the symbolic intention is revealed. For it truly represents, as the title of the work indicates, the first palpitation of consciousness in humanity just newly born, the first victory of reason over the bestiality of the prehistoric Ages.

Next I studied the *Saint John the Baptist* in the same way. And I saw that the rhythm of this figure could also be reduced, as Rodin had told me, to a sort of change from one equilibrium to another. The figure, which first rests on its left foot that pushes with all its force against the ground, seems to shift as the glance travels to the figure's right. One then sees the whole body leaning in this direction. Next the right leg advances, and the foot powerfully takes command of the earth. At the same time, the left shoulder is raised as if to bring the weight of the torso to its side and help the back leg come forward. Now the sculptor's science has consisted

precisely in imposing all these observations on the spectator in the order I have indicated them, in such a way that their succession gives the impression of movement.

Moreover, the gesture of the *Saint John the Baptist*, as well as that of *The Age of Bronze*, holds a spiritual meaning. The prophet moves with an almost automatic solemnity. One seems to hear his footsteps like those of the statue of the Commander.[1] One feels that a mysterious and formidable power stirs and pushes him. So walking, usually such a banal movement, here becomes grandiose because it is the fulfillment of a divine mission.

"Have you ever carefully examined men in the act of walking in high-speed photographs?" Rodin asked me suddenly.

And at my affirmative response:

"Well, what have you noticed?"

"That they never seem to be moving forward. In general, they seem to stand immobile on one leg or to hop."

"Exactly! Now take my *Saint John*. He is represented with two feet on the ground, but a high-speed photograph of a model moving in the same way would probably show the back foot already raised and moving forward. Or, on the other hand, the forward foot would not yet be on the ground if the back leg in the photograph occupied the same position as in my statue.

"For just this reason this photographed model would present the bizarre appearance of a man suddenly struck with paralysis and petrified in his pose, like the servants in Perrault's pretty tale of Sleeping Beauty who were all suddenly immobilized in their typical actions.

"And this confirms what I have just stated about movement in art. In high-speed photographs, although figures are caught in full action, they seem suddenly frozen in mid-air. This is because every part of their body is reproduced exactly at the same twentieth or fortieth of a second, and there is not, as in art, the gradual unfolding of a movement."

"I understand you very well, master," I said to him, "but it seems to me—excuse me for venturing this remark—that you contradict yourself."

"How is that?"

"Haven't you told me repeatedly that the artist should always copy Nature with the greatest sincerity?"

"Indeed, and I stick to this view."

"Well, when the artist interprets movement, he is in complete disagreement with photography, which is an unimpeachable mechanical witness. He evidently alters the truth."

"No," responded Rodin. "It is the artist who tells the truth and photography that lies. For in reality, time does not stand still. And if the artist succeeds in producing the impression of a gesture that is executed in several instants, his work is certainly much less conventional than the scientific image where time is abruptly suspended.

"And this is what condemns certain modern painters, who reproduce poses provided by high-speed photographs when they want to represent galloping horses.

"They criticize Géricault because in his *Race at Epsom* in the Louvre he paints horses galloping at full speed with their fore- and hindlegs thrown out simultaneously. They say that the photographic plate never shows this. Indeed, the high-speed photograph shows that when the front legs of the horse are stretched forward, the back legs, having sprung to propel the entire body, are already beneath the belly again ready to begin a new stride. Consequently, the four legs seem almost to meet in mid-air, giving the animal the appearance of having jumped up on the spot and having been immobilized in this position.

"Yet, I believe that Géricault rather than the photograph is correct because *his* horses have the appearance of running. This comes about because the spectator looks from back to front. He first sees the back legs make the effort to spring. Then, he sees the body stretch, and the forelegs reach for the ground in front. Géricault's representation is false in showing

these movements as simultaneous; it is true if the parts are observed in sequence. Only this truth matters since it is what we see and what impresses us.

"Note, furthermore, that when painters and sculptors bring together different phases of an action in the same figure, these do not proceed by reason or by artifice. They express quite naively what they feel. Their souls and their hands seem to be drawn to this gesture, and it is by instinct that they translate its development.

"Here, as everywhere in the domain of art, sincerity is the only rule."

For a few minutes I was silent, meditating on what Rodin had just told me.

"Haven't I convinced you?" he asked.

"Yes, indeed! But, at the same time that I admire this miraculous ability of painting and sculpture to condense several moments into a single image, I ask myself to what extent they compete with literature and, above all, with theater in the notation of movement.

"To tell the truth, I am inclined to think that this competition does not go very far, and that on this ground the masters of the brush and of the chisel are necessarily quite inferior to the masters of the word."

Rodin protested: "Our handicap is not what you think it is. If painting and sculpture can make figures move, they are not prohibited from attempting even more. And sometimes they succeed in equaling the dramatic art by representing in a single painting or sculptural group several successive scenes."

"Yes," I told him, "but this is because they cheat in some way. I imagine you are referring to those old compositions that celebrate the entire story of a character by representing him several times in the same panel in different situations.

"There is an example of this in the Louvre: a little Italian painting of the fifteenth century which recounts the legend of Europa. First you see the young princess playing in a

flower-studded meadow with her companions who help her mount the bull, Jupiter. Further on, the same heroine is shown full of fear while she is carried through the waves by the divine animal."

"There you have," said Rodin, "a very primitive technique which was used, however, by even great masters. At the ducal palace in Venice, the same fable of Europa has been treated by Veronese in an identical manner.

"But it is in spite of this deficiency that the painting of Caliari is admirable, and I was not at all alluding to such a puerile method. Surely you suspect that I disapprove of this.

"In order to make myself understood, I will ask you first if you can visualize Watteau's *Embarcation for Cythera*."

"Indeed, I seem to see it before my eyes."

"Then I will not have difficulty explaining myself. In this masterpiece, the *action*, if you just pay attention to it, starts in the foreground on the extreme right and ends in the background at the extreme left.

"What you see first in the foreground of the painting, in the cool shadows, near a bust of Cypris wreathed with roses, is a group composed of a young woman and her adorer. The man is wearing a 'love cloak,' on which is embroidered a pierced heart, the gracious insignia of the voyage he would like to make.

"Kneeling, he ardently implores the beauty to be swayed. But she answers him with an indifference that is perhaps false, and she seems to look with interest at the decoration of her fan."

"Beside them," I told him, "is a little cupid with his naked bottom resting on his quiver. He finds that the young woman is delaying too long, and he tugs at her skirt to get her to be less insensitive."

"That's it," said Rodin. "But the pilgrim's staff and the breviary of love still lie on the ground.

"This is a first scene.

"And here is a second: to the left of the group that I have

just described is another couple. His lady-love accepts the hand he holds out to help her get up."

"Yes. She is seen from the back, and she has one of those blond napes that Watteau painted with such voluptuous grace," I added.

"Further on is the third scene" [Rodin continued]. "The man takes his mistress by the waist in order to draw her along. She turns toward her companions whose delay makes her a little confused, and she allows herself to be led away with a consenting passivity.

"Now the lovers descend the bank and all together shove one another laughingly toward the boat. The men do not even need to use entreaties; these women cling to them.

"Finally the pilgrims make their friends board the skiff, its gilded chimera, festoons of flowers, and red silk banners rocking above the water. The boatmen, leaning on their oars, are ready. Already little cupids, carried by the breeze, flutteringly guide the voyagers toward the blue isle that emerges on the horizon."

"I see, master, that you like this painting since you have remembered the smallest details."

"It is a delight that one cannot forget.

"But have you noticed the way this pantomime unfolds? Now what do we have here, theater or painting? You cannot tell. So you see very well that an artist can, when he wants to, represent not only passing gestures but also an extended *action*, to use the current term in dramatic art.

"In order to succeed in this, he needs only to arrange his figures so that the spectator sees first those who begin this *action*, then those who continue it, and finally those who finish it.

"Do you want to see an example in sculpture?"

Then, opening a portfolio, he searched in it and pulled out a photograph.

"Here is *La Marseillaise* carved by the powerful Rude for one of the jambs of the Arch of Triumph," he said to me.

" 'To arms, citizens!' roars the bronze-armored Liberty at
the top of her voice as she cleaves the air with her spread
wings. She raises her left arm high above her in order to rally
all courageous people to her, and in the other hand she points
her sword toward the enemy.

"It is she, without any doubt, who is first noticed since she
is at the top of the whole work, and her legs part as if running,
compassing this sublime poem of war with a formidable cir-
cumflex accent.

"It even seems that you can hear her, for truly her stone
mouth vociferates as if it could break your eardrums.

"Now, as soon as she utters her call, you see the warriors
rush in.

"Here is the second phase of the action. A Gaul with the
mane of a lion waves his helmet as if to greet the goddess.
And here is his young son asking to accompany him. 'I am
strong enough, I am a man. I want to march!' the child seems
to be saying while clasping the hilt of a sword. 'Come!' says
the father who looks at him with a proud tenderness.

"Third phase of the action. A veteran bent under the
weight of his equipment makes an effort to join them since
everyone who possesses any vigor should march into com-
bat. Another old man overcome with years follows the sol-
diers with his good wishes, and the gesture of his hand seems
to reiterate his advice based on experience.

"Fourth phase. An archer bends his muscular back in order
to string his weapon. A bugler sounds a frenetic bugle call to
the troops. The wind makes the standard flap. The lances are
thrown foward as a group. The signal is given, and already
the fight is beginning.

"So, once again, here is a veritable dramatic composition
being played before us. But whereas the *Embarcation for Cy-
thera* evokes the delicate comedies of Marivaux, *La Marseil-
laise* is a bold tragedy by Corneille. Still I do not know which
of these two works I prefer since there is as much genius in
the one as in the other."

And looking at me with a shade of malicious defiance:

"You will no longer say, I think, that sculpture and painting are incapable of rivaling the theater?"

"Certainly not!"

At this moment I noticed in the portfolio, where he was refiling the reproduction of *La Marseillaise*, a photograph of his admirable *Burghers of Calais*.

"To prove to you," I resumed, "that I have profited from your teaching, let me apply it to one of your most beautiful works. For I see that you have put into practice yourself the principles that you have just revealed to me.

"In your *Burghers of Calais* here, I recognize a scenic succession quite similar to what you have noted in the masterpieces of Watteau and Rude.

"The figure in the middle draws the eyes first. It is, no doubt, Eustache de Saint-Pierre. He bows his grave head with its long, venerable hair. He shows no hesitation, no fear. He advances calmly, his eyes turn inward to his soul. If he staggers a little, this is because of the privations he has endured during a long siege. He is the one who inspires the others. He is the one who offers himself as the first of the six prominent persons, whose death, according to the condition of the conqueror, will save their fellow citizens from massacre.

"The burgher who is next to him is no less valiant. If he does not lament for himself, the surrender of his city causes him dreadful pain. Holding in his hand the key he will deliver to the English, he stiffens his entire body in order to find the strength to bear the inevitable humiliation.

"On the same plane as them, to the left, a less courageous man is seen. He walks almost too quickly. One would say that having made his resolution, he tries to shorten as much as possible the time that separates him from his execution.

"Behind these comes a burgher who, grasping his skull in his two hands, abandons himself to a violent despair. Perhaps he is thinking of his wife, of his children, of those who are dear to him, of those he will leave without support in life.

"A fifth notable puts his hand before his eyes as if to dispel

a terrifying nightmare. And he stumbles, so much has death frightened him.

"Finally, here is a sixth burgher, younger than the others. He still looks undecided. A terrible anxiety contracts his face. Is it the image of his lover that occupies his mind? Yet his companions are walking. He catches up and stretches forth his neck as if to offer it to the axe of Fate.

"Moreover, although these three men of Calais are less brave than the first three, they are not less worthy of admiration. For their sacrifice is more commendable because it costs them more.

"So, because of the authority and example of Eustache de Saint-Pierre, we see each of your burghers respond, more or less promptly, according to the temper of his soul. You see them coming under his influence little by little and deciding one after another to go.

"And there you have, unquestionably, the best confirmation of your ideas about the scenic value of art."

"If your kind attitude toward my work was not excessive, I would agree, my dear Gsell, for you have perfectly discerned my intentions.

"Above all, you have observed very well the ranking of my burghers according to their degree of heroism. In order to stress this effect even more, I wanted (you no doubt know this) to have my statues placed, one behind the other, in front of the Calais City Hall on the very paving of the square, like a living rosary of suffering and sacrifice.

"In this way my figures would have appeared to walk from the municipal hall to the camp of Edward III. The people of Calais today, who would have been almost elbow to elbow with them, would have felt the traditional solidarity that ties them to these heroes better. This would have had, I believe, a more powerful impression. But my project was rejected,

and a graceless, unnecessary pedestal was forced on me. They were mistaken, I am sure."

"Alas, artists always have to reckon with the routine opinion," I said to him. "They would be only too happy if they could realize one part of their beautiful dreams!"

5

Drawing and Color

Rodin has always drawn a great deal. He has used either the pen or the pencil. Years ago, he traced a contour with a pen, then added the darks and lights with a brush. The gouache washes executed in this way resembled copies of bas-reliefs or groups sculpted in the round. These were purely visions of a sculptor.

Since then, he has used the pencil to draw nudes, overlaying them with flesh-colored tints. These drawings are freer than the first ones. The poses are less fixed, more momentary. These are more the visions of a painter. The lines are sometimes strangely frenetic. Sometimes, an entire body will be fixed with a single line dashed off in one stroke. One recognizes the impatience of an artist who was afraid to let a very fleeting impression escape. The tint of the skin is washed in with three or four slashes that cut across the torso and the limbs. The modeling is produced summarily according to the density of the color deposited as it dries. Moreover, his brush is so hasty that it does not even take time to blend the drops that pool at the end of each stroke. These sketches fix very rapid gestures or else flexions so transitory that the eye can hardly grasp the whole movement in a half-second. These are no longer lines, this is no longer color, this is movement, this is life.

Even more recently, Rodin has ceased to model with the brush although he continues to use the pencil. He is content to shade by smudging the contour lines, using his finger as a

stump. This silver-gray scumble envelops the forms like a cloud. He makes them lighter and seemingly unreal. He bathes them in poetry and mystery. These last studies, I believe, are the most beautiful ones. They are at once luminous, lively, and full of charm.

As I was looking at several of these under the very eyes of Rodin, I told him how they differed from the finicky drawings that usually earn the praise of the public.

"It is true," he responded, "that what pleases the ignorant above all are the inexpressive minutiae of the execution and the false nobility of gestures. The common person does not understand a bold summary that passes rapidly over the useless details in order to stick to the truth of the whole. Nor does he understand the sincere observation that disdains theatrical poses in order to be concerned only with the entirely simple and even more moving attitudes of real life.

"People have wrong ideas on the subject of drawing, which are very difficult to correct; they believe that draftsmanship all by itself can be beautiful. It is only beautiful because of the truths, because of the feelings it expresses. People admire artists who were star pupils, who draw careful, calligraphic contours devoid of significance, and who pretentiously display their figures. People go into ecstasy over poses that are never seen in nature and that are considered artistic because they recall those thrust-out hips which Italian models indulge in when soliciting posing sessions. That is what is ordinarily called 'beautiful drawing.' In reality this is only sleight of hand, good for amazing the gawkers.

"Drawing in art is like style in literature. Style that is mannered, that behaves in a stiff way in order to be noticed, is bad. Good style is only what makes itself forgotten in order to concentrate the reader's attention on the subject treated, on the emotion rendered.

"The artist who parades his drawing and the writer who wants to attract praise to his style resemble the soldiers who

strut in their uniforms but refuse to go into battle, or else farmers who constantly polish their plowshare to make it shine instead of pushing it through the ground.

"Really beautiful drawing and style are those that you do not even think of praising because you are so interested in what they express. The same is true of color. There is really no beautiful style, no beautiful drawing, no beautiful color. There is only one beauty, the beauty of truth revealing itself. When a truth, a profound idea, or a powerful feeling explodes in a literary or artistic work, it is obvious that its style or color and its drawing are excellent. But this quality comes to them only as a reflection of the truth.

"The draftsmanship of Raphael is admired and this is right. But it is not for itself that it should be admired; it is not for the lines balanced with more or less skill. It should be liked for what it signifies. In fact, its whole merit lies in the delicious serenity of the soul that saw through Raphael's eyes and expressed itself with his hand, and in the love that seems to flow from his heart into all nature. Those who, lacking this tenderness, have tried to borrow from the master of Urbino his linear rhythms and the gestures of his figures, have only executed very insipid imitations.

"What should be admired in the drawing of Michelangelo is not the lines in themselves, the audacious foreshortenings and the skillful anatomy, but the thundering and desperate power of this Titan. The imitators of Buonarroti, who, lacking his soul, copied in painting his arched poses and tensed musculatures, have fallen into ridicule.

"What should be admired in Titian's color is not the more or less agreeable harmony, but the meaning it offers. It gives true pleasure only because it gives the idea of sumptuous and dominating sovereignty. The true beauty of Veronese's color comes from what it evokes, with the delicacy of its silvery shimmer, of the elegant cordiality of patrician festivals.

Rubens's colors are nothing in themselves. Their glow would be meaningless if it did not give the impression of life, happiness, and robust sensuality.

"There exists perhaps no work of art that draws its charm from its balance of lines and tones alone and that is addressed exclusively to the eyes. If, for instance, the stained-glass windows of the twelfth and thirteenth centuries delight the eyes with the velvety quality of their deep blues, the caress of their violets so soft, and their carmines so warm, it is because these tones translate the mystical felicity that the pious artists of these epochs hoped to enjoy in the heaven of their dreams. If certain Persian ceramics strewn with turquoise carnations are adorable marvels, this is because their nuances transport the soul through a strange effect into who know what valley of dreams and fairies.

"Therefore, the drawing and the arrangement of colors in every case express a meaning. Without this, they would have no beauty."

"But don't you fear that the disdain for craft in art . . . ?"

"Who is talking about disdaining it? Of course, craft is only a means. But the artist who neglects it will never achieve his goal, which is the interpretation of feeling, of idea. Such an artist would be like a rider who forgot to give oats to his mount.

"It is too obvious that if drawing is deficient, if the color is wrong, the most powerful emotion is incapable of being expressed. The mistakes in anatomy will make people laugh even though the artist wanted to move them. This is the disgrace that many young artists incur today. Since they have not done serious study, their lack of skill betrays them at every instant. Their intentions are good, but an arm that is too short, a leg that is knock-kneed, a perspective view that is inaccurate repels the spectators.

"The reason is, in effect, that no sudden inspiration can

replace the long work that is indispensable for giving the eyes the knowledge of forms and of proportions and for making the hand obedient to all the orders of the sentiment.

"When I say that craft should not be evident, my idea is not at all that the artist can bypass science.

"On the contrary, he must possess a consummate technique not to draw attention to his knowledge. No doubt, for the common man, the jugglers who perform flourishes with their pencils, or who manufacture dazzling pyrotechnics with color, or who write phrases enameled with bizarre words are the cleverest people in the world. But the greatest difficulty and the apex of art is to draw, to paint, to write with naturalness and simplicity.

"You have just seen a painting. You have just read a page. You have not noticed the drawing, the color, or the style, but you are moved to the bottom of your heart. Do not fear that you are mistaken: the drawing, the color, the style are technically perfect."

"But, master, can't some very moving masterpieces be weak in craftsmanship? Don't people say, for instance, that Raphael's paintings often have poor coloring and that Rembrandt's have questionable drawing?"

"People are mistaken, believe me.

"If Raphael's masterpieces delight the soul, the reason is that everything in them, the color, as well as the drawing, contributes to this enchantment.

"Look at the little *Saint George* in the Louvre, the *Parnassus* in the Vatican, look at the tapestry cartoons in the South Kensington Museum.[1] The harmony of these works is charming. Sanzio's color is entirely different from Rembrandt's, but it is precisely what his inspiration demands. It is light and enamel-like. It offers tonalities that are fresh, florid, and joyful. It has the eternal youth of Raphael himself. The color seems imaginary, but this is because the truth observed by the painter of Urbino is not that of purely material things. It

is the domain of feelings. It is a region where forms and colors are transfigured by the light of love.

"No doubt an uncompromising realist would judge this color inaccurate. But poets find it right. And what is certain is that the color of Rembrandt or of Rubens allied with the drawing of Raphael would be ridiculous and monstrous.

"Likewise, Rembrandt's drawing differs from Raphael's, but it is not less good.

"Sanzio's lines are soft and pure whereas Rembrandt's are often harsh and rough. The vision of the great Dutchman focuses on the coarseness of clothing, on the irregularities of old faces, on the callosities of plebian hands. To Rembrandt, beauty is only the acknowledged antithesis between the triviality of the physical envelope and the inner radiance. Now, how would he show this beauty comprised of apparent ugliness and moral grandeur if he tried to rival the elegance of Raphael?

"Admit that his drawing is perfect because it corresponds absolutely to the demands of his thought."

"So, according to you, it is a mistake to believe that the same artist cannot be both a good colorist and a good draftsman."[2]

"Certainly, and I don't know how this prejudice, which still enjoys such credit today, was established.

"If the masters are eloquent, if they take possession of us, this is clearly because they possess exactly all the means of expression that are necessary.

"I have just proved it to you regarding Raphael and Rembrandt. The same demonstration could be made for all great artists.

"For example, Delacroix has been accused of not knowing how to draw. On the contrary, the truth is that his drawing is marvelously matched to his color. Like his color, his drawing is abrupt, feverish, exalted. It has vivacity and fieriness. Like his color, his drawing is sometimes crazy; his drawing

is at its most beautiful then. Color and drawing—you cannot admire one without the other since together they make a whole.

"Where the demi-connoisseurs are mistaken is in admitting only one kind of drawing, that of Raphael. Or rather it is not even Raphael's drawing they admire but that of his imitators, David and Ingres. In reality, there are as many types of drawing and color as there are artists.

"People sometimes say that Albrecht Dürer has a hard and dry color. Not at all. But he is a German, a generalizer. His compositions are as precise as logical constructions. His figures are as solid as essential types. This is why his drawing is so emphasized and his color so purposeful.

"Holbein belongs to the same school. His drawing does not have the Florentine grace. His color does not have the Venetian charm. But with him line and color have a power, a gravity, an inner significance that perhaps is not found in any other painter.

"In general, it can be said that, among very reflective artists like these, drawing is particularly tight and color has a severity that asserts itself as inevitably as the truth of mathematics.

"On the other hand, among other artists, among those who are poets of the heart—like Raphael, Correggio, Andrea del Sarto—the line is more supple, and color has a more caressing tenderness.

"Among still others who are usually called *realists*, that is to say, those whose sensibility is more exterior—Rubens, Velázquez, Rembrandt, for example—the line has a lively appearance, brusqueness alternating with ease. And the color sometimes bursts in fanfares of sunshine, sometimes is muted in mist.

"So the means of expression with geniuses differ as much as their very souls do. One simply cannot say that with some of them the drawing and color are better or less good than with the others."

"Very well, master. But by suppressing the usual classifi-

cation of artists as draftsmen and colorists, you don't realize how much you will perplex the poor art critics who find it so useful.

"By chance, it seems to me that in your very words the lovers of categories could find a new principle of classification.

"Color and drawing, you say, are only the means, and it is the soul of the artist that it is important to know. I believe, then, that it would be fitting to group painters according to their turn of mind."

"This is true."

"For example, you could group those like Albrecht Dürer and Holbein who are logicians. You could make a separate category for those in whom feeling prevails; Raphael, Correggio, Andrea del Sarto, whom you have just cited together, would figure at the top of the elegists. Another category would be constituted by the masters who are interested in active existence, in the daily life, and the trio of Rubens, Velázquez and Rembrandt would be the most beautiful constellation of these.

"Finally, a fourth group could be made of artists like Claude Lorrain and Turner, who consider nature a tissue of luminous and fugitive visions."

"Without doubt, my dear friend. Such a classification would not lack ingenuity, and at any rate it would be more just than that which differentiates between colorists and draftsmen.

"However, because of the very complexity of art, or rather of human souls who take art for their language, any division runs the risk of being useless. So Rembrandt is often a sublime poet and Raphael often a vigorous realist.

"Let us endeavor to understand the masters, to love them, to be intoxicated with their genius. But let us refrain from labeling them like a pharmacist's drugs."

6

The Beauty of Woman

The Hôtel de Biron, which was the Convent of the Sacred Heart not long ago, is, as you know, presently occupied by tenants, among whom is the sculptor Rodin.[1] The master has other studios in Meudon and in Paris at the Dépôt des Marbres, but he prefers this one.[2]

It is, to tell the truth, the most beautiful abode an artist can imagine. Here the author of *The Thinker* has use of several large and very high rooms with white paneling and ornamented with charming mouldings and gold fillets.

One of these rooms, where he works, is like a rotunda and leads through high French windows into an admirable garden.

For several years this piece of land has been neglected. Yet one can still distinguish, among the rank weeds, the old lines of boxwood which bordered the walks. One can discern under the fantastic vines verdigris lattice arbors, and every spring there reappear hardy flowers in the beds among the grassy plants. Nothing is more deliciously melancholy than this progressive effacement of human work by wild nature.

At the Hôtel de Biron, Rodin spends almost all his time drawing.

In this monastic retreat, he enjoys isolating himself before the nudity of beautiful young women and recording in innumerable pencil sketches the supple attitudes they assume before him.

In the place where virgins received their education under

the tutelage of holy maidens, the powerful sculptor honors physical beauty with his fervor. Surely his passion for art is not less devout than the piety with which the pupils of the Sacred Heart were instructed.

One evening, I studied a series of his sketches with him, and I admired the harmonious arabesques through which he had reproduced the diverse rhythms of the human body on paper.

The contours, dashed off in uninterrupted lines, evoke the fire or abandon of the movements. Using his thumb to go back and blur the lines, he interpreted the charm of the modeling as a very light cloud.

While showing me his drawings, he saw again in his mind the models for them and in turn exclaimed: "Oh! the shoulders of that one, how lovely! This is a curve of a perfect beauty. My drawing is too heavy! I have tried, but . . . look, here is a second attempt after the same woman: it is closer, and yet . . . !

"Look at the bust of this one: the adorable elegance of the swelling. It has an almost unreal grace!

"And the hips of that one: what a marvelous undulation! How exquisitely the muscles are covered by the smooth surface! One should bow down before this!"

His gaze was lost in contemplation of his memories. He looked like an Oriental in the Garden of Mohammed.

"Master," I asked him, "do you find beautiful models easily?"

"Yes."

"So beauty is not very rare in our country?"

"No, I tell you."

"And does it last long?"

"It changes quickly. I will not say that woman is like a landscape that is constantly modified by the position of the sun, but the comparison is almost right.

"In true youth, that of virginal puberty, the body, full of

brand-new vigor, awakens in its svelte pride and seems both to fear and to summon love. This moment hardly lasts more than a few months.

"Without even speaking about the deformations caused by child-bearing, the fatigue caused by desire and the fever caused by passion rapidly slacken the tissues and relax the lines. The girl becomes a woman. This is another type of beauty, still admirable, but less pure."

"But, tell me, don't you think that ancient beauty greatly surpassed that of our time and that modern women are far from equaling those who posed for Phidias?"

"Not at all!"

"But the perfection of the Greek Venuses . . ."

"The artists then had eyes to see it whereas today they are blind. Here is all the difference. The Greek women were beautiful, but their beauty resided above all in the mind of the sculptors who represented them.

"Today there are very similar women. These are mainly the women of southern Europe. Modern Italian women, for example, belong to the same Mediterranean type as the models of Phidias. The essential characteristic of this type is the equal width of the shoulders and the hips."

"But didn't the Barbarian invasions of the Roman world alter the antique beauty because of interbreeding?"

"No. Even if we suppose that the barbarian people were less beautiful, less well balanced than the Mediterranean people, which is possible, time would have eliminated the defects produced by the mixing of blood and restored the harmony of the ancient type.

"In the union of the beautiful and the ugly, it is always beauty that triumphs. Nature, by divine law, constantly returns to the best, incessantly tends to the perfect.

"Close to the Mediterranean type there is also a northern type, which includes many French, as well as Germanic and Slavic women.

"In this type, the hips are strongly developed and the shoulders are narrower. This is the structure that you observe, for example, in the nymphs of Jean Goujon,[3] in the Venus of the *Judgment of Paris* painted by Watteau, and the *Diana* by Houdon.

"Besides, the chest is generally concave, whereas in the antique and Mediterranean type, the thorax is held erect.

"To tell the truth, all human types, all races have their beauty. You need only to discover it.

"With great pleasure I have drawn the little Cambodian dancers who once came to Paris with their sovereign.[4] The fine gestures of their slender limbs were a strange and marvelous seduction.

"I have made studies of the Japanese actress Hanako.[5] She has absolutely no fat. Her muscles stand out and project like those of the little dogs called fox terriers. Her tendons are so strong that the joints to which they are attached are as big as the limbs themselves. She is so strong that she can stand as long as she likes on one leg while raising the other before her at a right angle. Standing this way, she looks as if she were rooted to the ground like a tree. She has, then, an anatomy that is very different from European women, and yet it is very beautiful too in its unique power."

An instant later, taking up again an idea that is dear to him, he said to me: "In short, Beauty is everywhere. It is not that Beauty fails to come before our eyes but that our eyes fail to perceive it.

"Beauty is character and expression.

"Now, there is nothing in Nature that has more character than the human body. It evokes through its strength or its grace the most varied images. At one moment, it resembles a flower: the bending of the torso imitates the stem, while the smile of the breast, head, and gleaming hair correspond to the blooming of the corolla. At another moment, it recalls a supple liana, a shrub with a fine and daring camber. 'When I

see you,' Ulysses said to Nausicaa, 'I think I am seeing again a certain palm tree which grew on Delos by the altar of Apollo with a powerful thrust toward the sky.'

"Another time, the human body curved back is like a spring, like a beautiful bow from which Eros aims his invisible arrows.

"Yet another time, it is an urn. I have often had a model sit on the floor and turn her back to me with her arms and legs drawn before her. In this position, only the silhouette of the back, which narrows at the waist and widens at the hips, appears, and this forms a vase with an exquisite contour: the amphora that holds the life of the future in its flanks.

"The human body is above all the mirror of the soul and from this comes its greatest beauty:

> Flesh of woman, ideal clay, oh marvel,
> Oh sublime penetration of the spirit
> Into the loam that the ineffable Being molds,
> Matter in which the soul shines through its shroud,
> Mud in which we see the finger marks of the Divine Sculptor
> Revered mire calling for kisses and love,
> So holy that you do not know, so has love conquered,
> So is the soul drawn toward this mysterious bed,
> Whether this pleasure is but a thought,
> And that you only, in the hour when your senses are on fire,
> Embrace Beauty without believing that you embrace God![6]

"Yes, Victor Hugo understood it well! What we adore in the human body, even more than its beautiful shape, is the interior flame that makes it transparent."

7

Souls of Yesterday, Souls of Today

Several days ago, Rodin was on his way to the Louvre to see the busts of Houdon, and I accompanied him.

As soon as we were before the *Bust of Voltaire*, the master exclaimed: "What a marvel! This is the personification of wiliness.

"The slightly oblique glance seems to look out for some adversary. The pointed nose resembles that of a fox. It seems to ceaselessly sniff out, on one side and the other, abuse and ridicule. You can see it quivering. And the mouth: what a masterpiece! It is surrounded by two furrows of irony. It seems to mutter I don't know what sarcasm.

"This Voltaire produces the impression of a very crafty, gossipy old woman. He is at once so lively, so sickly, and so little masculine."

And, after a moment of contemplation: "These eyes! I return to them. They are filmy. They are translucent.

"One could say just as much about all the busts of Houdon. This sculptor could render, better than a painter or a pastelist, the transparency of the pupils. He has perforated, drilled, incised them. He has raised burrs, making the eyes spirited and individualized. Those burrs lighten or darken and imitate so well the scintillating light of the pupil that we could believe it was real. And what diversity in the gazes of all these faces. Shrewdness with Voltaire, geniality with Franklin, authority with Mirabeau, seriousness with Washington, joyfulness with Mme. Houdon, mischievousness

with the sculptor's daughter and with the two delightful little Brongniarts.

"The gaze is more than half the expression for this sculptor. Through the eyes he deciphered souls. And they did not keep any secret from him. Then there is no need to ask whether these busts were likenesses."

At this point, I stopped Rodin.

"You think then that likeness is a very important quality?"

"Certainly. Indispensable."

"Many artists, however, say that busts and portraits lacking resemblance can be very fine. I remember, by the way, a witticism attributed to Henner.[1] When a lady whose portrait he was painting complained to him that it did not resemble her, he responded in his Alsatian accent: 'What, Madame! When you are dead, your heirs will be very happy to own a beautiful portrait painted by Henner and they will worry very little whether it looks like you.' "

"It is possible that this painter said this, but no doubt it was just a quip that did not correspond to his real thinking. I cannot believe that he had false ideas about an art in which he showed much talent.

"Let us first come to an understanding of what kind of resemblance the portrait and the bust demand.

"If the artist only reproduces the superficial features like a photographer, if he exactly records the diverse features of a physiognomy, but without relating these to character, he does not deserve our admiration. The resemblance he should achieve is that of the soul. Only this matters. This is what the sculptor or the painter must seek behind the mask.

"In a word, every feature must be *expressive*; it must help reveal the psyche."

"Does the face sometimes not accord with the soul?"

"Never," said Rodin.

"But remember the precept of La Fontaine: 'You should not judge people by their appearance.' "

"This maxim, in my opinion, is addressed only to casual

observers. The appearance can fool their hasty examination. La Fontaine writes that the baby mouse took the cat for the sweetest of creatures. Now he speaks of a baby mouse, that is to say, someone who is inexperienced and lacks the critical faculty. The appearance itself of the cat warns anyone who studies it attentively that there is cruelty hidden beneath this hypocritical somnolence. A physiognomist knows perfectly well how to distinguish between false and true kindness.[2] And this is precisely the role of the artist: to reveal truth, even when it lies beneath dissimulation.

"To tell the truth, there is no artistic work that requires as much penetrating insight as the bust and the portrait. People sometimes believe that the profession of the artist demands more manual skill than intelligence. It suffices to look at a good bust to redress this error. Such a work is the equivalent of a biography. Houdon's busts, for instance, are written like chapters of memoirs. Period, ancestry, profession, personal character—everything is indicated.

"Here is Rousseau opposite Voltaire. He has much keenness in his glance. This is a quality common to all the personages of the eighteenth century. They were critics. They examined every principle accepted at the time. They had scrutinizing eyes.

"Now their personal origins. Rousseau is a plebeian from Geneva. Where Voltaire is aristocratic and distinguished, he is unpolished and almost common: prominent cheekbones, short nose, square chin. You can recognize the former servant and son of a watchmaker.

"Profession. This is the philosopher: forehead sloping and meditative, classical appearance accentuated by the classical fillet circling the head. A wilfully savage appearance, hair neglected, a certain resemblance to some Diogenes or some Menippus. This is the advocate of the return to Nature and primitive life.

"Individual character. A general wincing of the face. This is the misanthropist: contracted eyebrows, worried furrow

of the forehead. This is the man who complains, often with reason, of being persecuted.

"Tell me, isn't this the best commentary for the *Confessions*?

"Mirabeau.

"The period. Provocative attitude, wig in disorder, costume disarrayed. The wind of the revolutionary tempest blows on this wild beast ready to roar.

"Background. A domineering look, beautiful, well-arched eyebrows, a lofty forehead: this is the former aristocrat. But the democratic heaviness of the jowls riddled by smallpox and of the neck sunk into the shoulders won for the Comte de Riquetti the understanding of the Third Estate, whose interpreter he became.

"Profession. He is the tribune. His mouth protrudes like a megaphone, and in order to project his words Mirabeau raises his head because he was small like most orators. In this kind of man, as a matter of fact, nature develops the *chest* at the expense of height. His eyes focus on no one but hover over a large assembly. It is a look at once imprecise and superb. And, tell me, isn't it a miraculous feat that the artist in a single head can evoke a whole crowd, even more, an entire country that listens?

"Finally, the individual character. Notice the sensuality of the lips, of the double chin, of the quivering nostrils. You will recognize his tainted character: his habit of debauchery and his need for pleasures.

"Everything is there, I tell you.

"It would be easy to sketch a similar series of remarks for each of Houdon's busts.

"Here is another, Franklin. A heavy appearance, large drooping cheeks: this is the former workman. Long hair of an apostle, a certain kindness: this is the popular moralizer, this is Poor Richard. A large, obstinate forehead, sloping forward: indication of the tenaciousness Franklin showed in instructing himself, elevating himself, becoming an illustrious

scientist, and then in emancipating his native land. Astuteness in the eyes and at the corner of the mouth: Houdon has not been fooled by Franklin's general massiveness and has divined the cautious realism of the calculator who made a fortune, the guile of the diplomat who unlocked the secrets of English politics.

"Here, in the flesh, is one of the ancestors of modern America.

"So, in these admirable busts do we not find in snatches the chronicle of a half-century?"

I am convinced.

Rodin pursued: "As in the best written accounts, what is pleasing above all in these memoirs in terracotta, marble, and bronze is the sparkling grace of the style, the lightness of the hand that wrote them, the generosity of the beautiful soul, so French, who composed them. Houdon is Saint-Simon without his aristocratic prejudices.[3] He is as witty as and more generous than Saint-Simon. Ah, the divine artist!"

I did not fail to verify the passionate interpretation given by my companion of the busts themselves.

"It must be difficult," I said to him, "to penetrate personalities so deeply."

To this Rodin replied: "Yes, indeed." Then with a touch of irony: "The greatest difficulties for the artist who models a bust or paints a portrait, however, do not come from the work he executes. They come from the client who employs him.

"By a strange and fatal law, the one who commissions his image is always determined to fight the talent of the artist he has chosen.

"It is very rare that a man sees himself as he is, and even if he know himself, it is disagreeable to him for an artist to portray him with sincerity.

"He asks to be represented in his most neutral and most common aspect. He wants to be an official or worldly puppet. He is pleased that his function, his rank in society, com-

pletely effaces the man in him. A magistrate wants to be a robe, a general, a tunic braided with gold.

"They care little what can be read in their soul.

"This explains, moreover, the success of so many mediocre portraitists and makers of busts, who confine themselves to rendering the impersonal appearance, the trimmings, the formal attitude of their clients. These are the artists who are ordinarily most in favor because they give their model a mask of richness and solemnity. The more bombastic a bust or a portrait, the more it resembles a stiff and pretentious doll, and the more the client is satisfied.

"Perhaps it was not always so.

"Certain lords of the fifteenth century, for example, took pleasure, it seems, in seeing themselves represented in the medals of Pisanello as hyenas or vultures. They were no doubt proud to resemble no one. Or rather, they liked, they venerated, art, and they accepted the severe frankness of artists as a penance imposed by a religious adviser.

"Titian did not hesitate to give Pope Paul III a marten's snout or to underline the domineering harshness of Charles V or the salacity of Francis I, and it does not appear that his reputation was diminished in their eyes. Velázquez portrayed Philip IV as a very elegant but worthless man and reproduced without flattery his pendant jaw. Nevertheless, the artist remained in the king's good graces. And so the Spanish monarch acquired for posterity the very great glory of having been the protector of a genius.

"But the men of today are so made that they fear the truth and adore the lie.

"This repugnance for artistic sincerity is revealed even with our most intelligent contemporaries.

"It seems that they are annoyed at being shown as intelligent in their busts. They want to look like fops.

"And even the most beautiful women, that is to say, those whose lines offer the most style, have a horror of their own

beauty when a sculptor with talent interprets it. They implore him to make them ugly by giving them a babylike and insignificant physiognomy.

"So it is a hard battle to execute a good bust. It is important not to weaken but to remain honest to one's self. So much the worse if the work is turned down! Rather, so much the better since this is most often evidence that it is of quality.

"As for the client, who, although unhappy, accepts a successful work, his bad feeling is only short-lived. Since connoisseurs soon pay him so many compliments on his bust, he ends up admiring it. And he then declares most naturally that he has always found it excellent.

"It should be noticed, moreover, that busts executed gratis for friends or relatives are the best. This is not just because the artist knows the models better since he sees them continually and cherishes them. It is above all because the lack of charge for his work grants him the liberty to carry it out exactly as he pleases.

"Moreover, even when offered as gifts, the most beautiful busts are often turned down. In this type of art, masterpieces are generally considered insults by those for whom they are intended. The sculptor must resign himself to this and get all his pleasure, all his reward, from doing well."

This psychology of the public with whom artists do business, amused me a lot. But, to tell the truth, much bitterness was mixed in Rodin's irony.

"Master," I said to him, "among the problems of the sculptor, there is one you seem to have omitted. This is making the bust of a client whose head is expressionless or who betrays an obvious stupidity."

Rodin began to laugh: "This cannot count as a problem," he answered. "Don't forget my favorite saying: 'Nature is always beautiful.' You only need to understand what Nature shows us. You speak of an expressionless face. There is no such thing for the artist. For him, every human head is inter-

esting. If the sculptor stresses, for example the insipidity of a physiognomy or shows us a fool absorbed by the desire to parade before the world, this is a beautiful bust.

"Incidentally, what one calls a limited intellect [*un esprit borné*] is often only intellect [*une conscience*] that has not blossomed because it has not received the education that would permit it to expand. In this case, the face offers the mysterious and captivating spectacle of an intelligence that seems to be enveloped by a veil.

"Finally—what more can I say—even in the most insignificant head there dwells life, magnificent power, inexhaustible material for masterpieces!"

★ ★ ★

Some days later, I saw again in Rodin's studio at Meudon casts of several of his most beautiful busts, and I seized this occasion to ask him about the memories they held for him.

There was his *Victor Hugo*, lost in his meditations, his forehead strangely furrowed and volcanic, his hair windswept, like white flames bursting from his skull. This was the very personification of modern lyricism, profound and tumultuous.

"It was my friend Bazire," Rodin told me, "who introduced me to Victor Hugo. Bazire was the editor of the newspaper *La Marseillaise*, later of *L'Intransigeant*. He adored Victor Hugo. It was he who launched the idea of publicly celebrating the eightieth anniversary of the great man. As you know, the ceremony was both touching and solemn. From his balcony, the poet greeted the immense crowd gathered before his house to acclaim him, like a patriarch blessing his family. Hugo retained a tender gratitude for the one who had organized that day. And this is why Bazire introduced me easily to Hugo.

"Unfortunately, Victor Hugo had just been martyred by a mediocre sculptor named Villain [*sic*]. He had inflicted

Hugo with thirty-eight sittings, only to end up with a bad bust. So when I timidly expressed my desire to reproduce in my turn the features of the author of *Les Contemplations*, his Olympian brows frowned terribly.

" 'I cannot stop you from working,' he said, 'but, I'm warning you, I will not pose. I will not change any of my habits for you; manage as best you can.'

"So I came and drew quickly a great number of sketches in order to facilitate my subsequent modeling. Then I brought my turntable and some clay. Naturally, I could only install this messy equipment on the veranda, and since Victor Hugo usually sat with his friends in the salon, you can imagine the difficulty of my task. I would study the great poet attentively, trying to engrave his image in my memory, then quickly run to the veranda to fix in clay the memory of what I had just seen. But often, on the way back, my impression weakened so that when I arrived at my turntable, I did not dare to make a single mark with my boaster and had to resolve to return to my model.

"As I was about to finish my work, Dalou asked me to give him access to Victor Hugo, and I gladly did him this favor.[4]

"But the glorious old man died soon after, so Dalou was only able to make his bust from a cast made from the dead man's face."

Then Rodin led me to a showcase that held a peculiar block of stone. It was a keystone, one of those wedge-shaped blocks that architects insert in the center of their arches to hold the curve. On the anterior face of this stone was sculpted a mask, squared along the jaws and the temples to follow the shape of the block. I recognized the face of Victor Hugo.

"Imagine this keystone at the entrance of a building dedicated to poetry," the master sculptor said to me.

I had no trouble imagining this beautiful vision. The forehead of Victor Hugo bearing thus the weight of a monumental arch would symbolize the genius who supported all the thinking and all the activity of an age.

"I offer this idea to the architect who is willing to carry it out," Rodin told me.

Nearby, in the studio of my host, there was the cast of the bust of Henri Rochefort. This head of a rebel is familiar: with his forehead puckered like that of a quarrelsome child who constantly argues with his companions, the incendiary forelock that seems to wave like a signal to riot, his mouth twisted by irony, his raging goatee. Here is a continual revolt, the very spirit of criticism and combativeness. Admirable mask in which is reflected an entire segment of contemporary mentality.

"It was also through Bazire," Rodin told me, "that I entered into relations with Henri Rochefort, who was his editor-in-chief. The famous polemicist agreed to pose for me. It was enchanting to listen to him because he had such joyful animation. But he couldn't stay still for a minute. He pleasantly reproached me for my professional conscience. He said, laughing, that I spent by turns one session adding a pellet of clay and the other removing it.

"When, some time later, his bust won the approbation of connoisseurs, he joined their praises without reservation, but he would never believe that my work had remained exactly as it was when I removed it from his place. 'You have retouched it a lot, haven't you?' he often repeated to me. Actually, I had not so much as given it a stroke of my thumb."

Then, Rodin putting one hand over the forelock of the bust and the other over the goatee, asked me: "Now what impression does it make on you?"

"It looks like a Roman emperor."

"That is precisely what I wanted you to say. I have never rediscovered such a pure classical Latin type as Rochefort."

If the old adversary of the empire ever learns of this paradoxical resemblance of his profile to that of the Caesars, we can bet it will make him smile.

When, a moment earlier, Rodin had spoken of Dalou, I

saw again in my mind's eye the bust he had made after this sculptor, which is in the Musée du Luxembourg.

It is a proud and provocative head: the thin and sinewy neck of a child of the working-class neighborhoods, the bushy beard of the artisan, a wincing forehead, with the ferocious eyebrows of the former Communard, the feverish and arrogant air of the intractable democrat.[5] At the same time, he has large and noble eyes, and in the design of the temples delicate incurvations reveal the passionate lover of Beauty.

To a question I asked, Rodin responded that he had modeled this bust at the moment when Dalou, taking advantage of the amnesty, had returned from England.

"He never took possession of it," he told me, "since our relations ceased soon after I introduced him to Victor Hugo.

"Dalou was a great artist, and several of his sculptures have a superb decorative rhythm, which links them to our most beautiful groups of the seventeenth century.

"He would never have produced anything but masterpieces had he not had the weakness of desiring an official position. He aspired to become the Le Brun of our Republic and something like the conductor of all contemporary artists.[6] He died before attaining this.

"One cannot practice two professions at the same time. All the activity expended in acquiring useful relations and in playing a role is lost to Art. The schemers are not stupid: when an artist wants to play their game, he must exert as much effort as they do, and then there is almost no time left for his work.

"Besides, who knows? If Dalou had just stayed in his studio to pursue his own work peacefully, he would no doubt have given birth to marvels so great that their beauty would have instantly struck everyone. Then perhaps universal opinion would have bestowed on him this artistic royalty for which he had exerted all his skill.

"His ambitious effort, however, was not entirely in vain, for his influence at City Hall resulted in one of the most majestic masterpieces of our time. It is he who, despite the undisguised hostility of the administrative committees, had Puvis de Chavannes commissioned to do the decoration of the Prefect's staircase. And you know with what heavenly poetry this great painter illuminated the walls of the municipal building."

These last words turned the conversation to the bust of Puvis de Chavannes.

For those who knew the man, this image is a striking resemblance.

"He held his head high," said Rodin. "His skull, solid and round, seemed made to wear a helmet. His bulging thorax seemed accustomed to wearing a cuirass. One can easily imagine him at Pavie fighting next to Francis I for the cause of honor."

In his bust, as a matter of fact, you rediscover the aristocrat of the old line. The broad forehead and the majestic brows reveal the philosopher, and the calm gaze surveying the vast expanses reveal the great decorator, the sublime landscapist.

There is no modern artist for whom Rodin professes more admiration, more tender respect, than for the painter of Saint Geneviève.

"To think he has lived among us," exclaimed Rodin. "To think that this genius worthy of the most radiant periods of art spoke to us, that I have seen him, that I have shaken his hand.

"It is as though I had shaken hands with Nicolas Poussin."

Oh, how well put! To project a contemporary figure back into the past in order to equate him to one of the most radiant figures of that time and to be moved by the thought of the physical contact with this demi-god. Is there a more touching homage?

Rodin continues: "Puvis de Chavannes did not like my bust, and this was one of the disappointments of my career.

He felt that I had made a caricature of him. However, I am certain that I expressed in my sculpture all the enthusiasm and veneration I felt for him."

The bust of Puvis made me think about the bust of Jean-Paul Laurens, also at the Musée du Luxembourg.

Round head, mobile and exalted, almost breathless, face: it is the man from the south. There is something archaic and unpolished in the expression. The eyes seemed haunted by very far off visions. This is the painter of half-savage periods when men were robust and impetuous.

Rodin said to me: "Laurens is one of my oldest friends. I posed for one of the Merovingian warriors present at the death of Saint Geneviève in his Pantheon murals.

"His affection has always been constant. He helped me obtain the commission for *The Burghers of Calais*. While that commission probably gave me hardly any profit since I delivered six bronze figures for the price offered for one, I am deeply grateful to Laurens for having pushed me to create one of my best works.

"I had great pleasure in making his bust. He reproached me amicably for having represented him with his mouth open. I told him that because of the shape of his skull, he was very probably descended from the ancient Visigoths of Spain and that this type was characterized by the protrusion of the lower jaw. I don't know if he accepted the accuracy of this ethnographic observation."

At this moment, I caught sight of a bust of Falguière.

This seething and eruptive character had a face that was furrowed by wrinkles and bulges like the earth disrupted by storms, the mustache of a Napoleonic veteran, hair that was thick and short.

"He was a little bull," Rodin told me.

And, in fact, I noticed the thick neck with the folds of skin in front like a dewlap, the square forehead, the bent, obstinate head ready to charge.

A little bull! Rodin often made these comparisons with the

animal kingdom. This one, with his long neck and automatic gestures, is a bird that pecks right and left. Another personage who is too nice, too coquettish, is a King Charles spaniel, etc. These comparisons evidently facilitate the classification of physiognomies into general categories.

Rodin informed me of the circumstances under which he became friends with Falguière.

"It was," he said, "when the Société des Gens de Lettres turned down my *Balzac*.[7] Falguière, who was given the commission, expressed by his friendship that he did not at all approve of my detractors. To reciprocate for his sympathy I proposed making his bust. Incidentally, he found it quite successful when I had finished it. I know that he even defended it against those who criticized it in his presence. And, in his turn, he executed my bust, which is very beautiful."

Finally at Rodin's I saw a bronze cast of the bust of Berthelot.

He made it only one year before the death [1907] of the great chemist. The scientist is reflecting on the work he has accomplished. He meditates. He is alone with himself; alone against the collapse of old beliefs; alone before nature, some of its secrets penetrated by him, yet still so immensely mysterious; alone on the brink of the infinite abyss of the heavens. His tormented forehead, his lowered eyes are painfully melancholy. This beautiful head is like the emblem of modern intelligence, which, sated with thinking, almost weary of thought, ends by asking: "What's the use?"

The busts I had just admired and about which my host had just spoken to me now gathered in my mind and seemed to me the richest treasure of documents on our time.

"If Houdon," I said to Rodin, "wrote the memoirs of the eighteenth century, *you* have composed those of the late nineteenth century.

"Your style is more biting, more violent than that of your predecessor. The expressions are less elegant, but even more natural and more dramatic, if I may say so.

"Skepticism, which in the eighteenth century was distinguished and rebellious, with you has become harsh and poignant. Houdon's personages were more sociable, yours are more self-absorbed. Houdon's leveled their criticisms at the abuses of a regime; yours seem to put in question the value of human life itself and to feel the anguish of unrealizable desires."

Then Rodin said:

"I have done my best. I have never lied. I have never flattered my contemporaries. My busts have often displeased because they were always very sincere. They certainly have one merit: truth. May this serve as beauty!"

8

Thought in Art

One Sunday morning, finding myself with Rodin in his studio, I stopped before the cast of one of his most striking works.

This represents a beautiful young woman whose body is painfully twisting. She seems prey to some mysterious torment. Her head is sharply bent. Her lips and eyes are closed, and she seems to sleep. But the anguish of her features reveals the dramatic conflict of her spirit.

What completes our surprise, when we look at it, is that she has neither arms nor legs. It seems that the sculptor broke them off in a fit of dissatisfaction with himself.

And you cannot help regretting that such a powerful figure is incomplete. You deplore the cruel amputations to which she has been submitted.

I expressed this feeling, despite myself, to my host.

"Why are you reproaching me?" he said with some surprise. "Believe me, I left my statue in this condition on purpose. It represents meditation. This is why she has no arms for taking action, nor legs for walking. Haven't you noticed that when reflection is carried very far, it suggests such plausible arguments for the most opposite decisions that, in effect, it recommends inertia?"

These few words made me reconsider my first impression, and I could admire, without reserve, the lofty symbolism of the image before my eyes.

I now understood that this woman was the emblem of human intelligence pressed by problems it cannot solve,

haunted by the ideal it cannot realize, obsessed by an infinite it cannot embrace. The contraction of this torso marked the torment of thinking and its glorious, but fruitless, obstinacy in going deeply into questions it is incapable of answering. And the mutilation of the limbs indicates the insurmountable disgust felt by contemplative souls for the practical life.

However, I then recalled a criticism often provoked by the works of Rodin, and without agreeing with it I submitted it to the master to see how he would reply.

"Writers," I said to him, "can only applaud the substantial truths expressed by all your sculptures.

"But some of your critics blame you precisely for having an inspiration that is more literary than sculptural. They maintain that you have skillfully won the approval of writers by furnishing them with themes that give free rein to their rhetoric. And they declare that art does not allow so much philosophical ambition."

"If my modeling is bad," Rodin responded heatedly, "if I commit faults in the anatomy, if I interpret movements poorly, if I ignore the science of animating marble, these critics are a hundred times right.

"But if my figures are correct and full of life, then what do they criticize? And by what right would they prohibit me from attaching certain meanings to them? What do they complain about if, in addition to my professional work, I offer them ideas, and if I enrich forms capable of seducing the eye with signification?

"Furthermore, it is certainly wrong to imagine that true artists can be content with being skillful workers and do not need intelligence.

"On the contrary, it is indispensable to them even in painting or in carving the images that seem the most devoid of spiritual ambitions and that are only destined to charm the eye.

"When a good sculptor models a statue, whatever it represents, he must first conceive the general movement force-

fully. Then, until the end of his task, he must keep his idea for the entire composition strongly and clearly in mind. In this way, he can always compare and closely relate the smallest details of his work to it. And this is not done without an enormous amount of thinking.

"Probably what made people believe that artists do not need intelligence is that many of them appear to lack it in everyday life. Biographies of famous painters and sculptors abound in anecdotes about the naivety of certain masters. But it must be said that great men, meditating ceaselessly on their works, are frequently absent-minded in day-to-day existence. It must be said, above all, that many artists, as intelligent as they may be, seem limited simply because they lack that ease with words and repartee, which for casual observers is the only sign of cleverness."

"Certainly," I said, "one cannot without injustice question the cerebral vigor of great painters and great sculptors.

"But, to come back to a more specific question, is there not a dividing line between art and literature that artists should not cross?"

"I must confess," Rodin responded, "that for my part, I don't take kindly to 'no trespassing' signs.

"There is no rule, in my opinion, that can stop a sculptor from creating a beautiful work in his own way. And what does it matter if this be sculpture or literature if the public finds in it reward and pleasure? Painting, sculpture, literature, music are closer to one another than is generally believed. They express all the feelings of the human soul in the presence of nature. Only the means of expressing them vary.

"But if by the methods of his art, a sculptor succeeded in suggesting impressions that literature or music ordinarily provide, why pick a quarrel with him? Lately a writer criticized my *Victor Hugo* at the Palais Royal declaring that it was not sculpture but music.[1] And he added naively that this

work brings to mind a symphony by Beethoven. If this were only true!

"I do not deny, however, that it is useful to meditate on the differences between literary and artistic means of expression.

"To begin with, literature has this peculiarity of being able to express ideas without having recourse to images. It can say, for example, that a 'very deep reflection very often results in inaction' without needing to represent a pensive woman who is prevented from moving.

"And this capacity for juggling abstractions by means of words, perhaps, gives literature an advantage over the other arts in the realm of thought.

"It should also be noted that literature develops stories that have a beginning, a middle, and an end. It connects various events from which it draws a conclusion. It makes characters act and shows the consequences of their conduct. In this way, the scenes that literature evokes reinforce one another because they are sequential; the scenes take on their value only because of the part they play in the progression of the plot.

"The formal arts are different. They only represent a single phase of an action. This is why painters and sculptors are perhaps wrong in drawing their subjects from writers, as they so often do. In fact, the artist who interprets one part of a narrative must assume that the remainder of the text is known. His work necessarily depends on the writer's work: it acquires full meaning only when it is illuminated by the facts that precede and follow.

"When the painter Delaroche takes from Shakespeare, or rather his pale imitator Casimir Delavigne, the subject of the *Children of Edward* huddled together, you must know, in order to be interested in this spectacle, that these are heirs to a throne, that they are locked up in prison, and that assassins, sent by a usurper, are about to appear in order to murder them.

"When Delacroix—and I apologize for citing him next to

the very mediocre Delaroche—borrows the subject of *The Shipwreck of Don Juan* from a poem by Lord Byron and shows us a storm-tossed boat in which sailors draw pieces of paper from a hat, you must know, in order to understand this scene, that these unfortunate starving men are deciding which of them will serve as food for the others.

"By treating these literary subjects, these two artists have made the mistake of painting works that do not carry their complete meaning in themselves.

"While Delaroche's painting is bad because the drawing is cold, the color harsh, the sentiment melodramatic, Delacroix's painting is admirable. This is because the boat really pitches on the green waves, because hunger and distress tragically convulse the faces of these ship-wrecked people, because the somber fury of the color portends some horrible crime. And, finally, even if the story of Byron is cut short in this painting, the wild, feverish, and sublime soul of the painter is certainly there completely.

"Here is the moral lesson of these two examples: when, after mature consideration, you set out the most reasonable limitations for art, you may legitimately blame mediocre artists if they don't observe them, but you will be surprised to discover that geniuses disregard them almost with impunity."

While Rodin was talking, my eyes encountered in his studio a cast of his *Ugolino*.

This is a figure of grandiose realism. It does not recall at all the group by Carpeaux: it is even more pathetic, if this is possible. In Carpeaux's work, the Pisan count, tortured by rage, hunger, and the pain of seeing his children near death, bites both of his fists. Rodin has shown the drama at a later moment. The children of Ugolino have died. They lie on the ground, and their father, changed to a beast by his hunger pangs, crawls on his hands and knees over their cadavers. He leans toward their flesh, but at the same time violently throws his head to the side. In him is let loose a terrible combat be-

tween the brute who wants to eat his fill and the thinking being, the loving being, who is horrified by such monstrous sacrilege. Nothing is more poignant!

"There you have," I said to the master sculptor, "an example to add to *The Shipwreck of Don Juan* as confirmation of your words.

"For certainly you must have read *The Divine Comedy* to understand the circumstances of the martyrdom of your Ugolino. Yet even if one were unfamiliar with the triplets of Dante, one could not avoid being moved by the horrible, inner torment expressed by the pose and the features of your figure."

"In truth," Rodin admitted, "when a literary subject is so well known, the artist can treat it without fear of not being understood.

"Still it is better, in my opinion, for the works of painters and sculptors to contain their entire interest in themselves. Art, indeed, can provide thinking and dreaming without having any recourse to literature. Instead of illustrating scenes from poems, art should only use very clear symbols that do not rely on any written text.

"This has generally been my method, and I have been happy with it."

What my host had just described was proclaimed by his sculptures surrounding us, using their mute language. Indeed, there I saw casts of several of his works that particularly radiated ideas.

I started to look at them.

I admired the replica of *Thought*, which is in the Musée du Luxembourg.

Who is not familiar with this unique work?

It is a very young, a very fine head of a woman, with features of a miraculous delicacy and subtlety. It is bent and haloed by a revery that makes the head seem immaterial. The flaps of a light, close-fitting cap that covers the forehead seem like the wings of its dreams. But the neck and even the chin

are locked in a rough and massive block of marble, as if in a cangue from which they cannot free themselves.

And the symbolism is easily understood. Immaterial Thought springs from the breast of inert Matter and illumines it by the reflection of its splendor, but in vain does it try to escape the heavy shackles of reality.

I also contemplated *Illusion, Daughter of Icarus.*

It is an angel of ravishing youth. While it was flying with its great wings, a brutal gust of wind precipitated it to earth, and lamentably its charming face has just crashed into a rock. But its wings remain intact, still flapping in space, and since it is immortal, one realizes that it will again take wing only to fall once more, just as cruelly as the first time, then again and again. The untiring hopes and eternal setbacks of illusion!

My attention was then attracted to a third sculpture: *The Centauress.*

The human bust of the fabulous creature reaches desperately toward a goal that its stretching arms cannot touch, but its back hooves, rooted to the ground, digging themselves in, and the broad rump, almost squatting in the mire, will not budge. The poor monster is composed of this frightful pulling apart of the two natures. Image of the soul whose ethereal impulses remain miserably captive in the vile body!

"In themes of this kind," Rodin told me, "the idea, I believe, can be read without effort. They awaken the imagination of the spectator without extraneous assistance. And yet, far from circumscribing the imagination by narrow boundaries, they give the impulse for it to wander according to its fancy. This, I believe, is the role of art. The forms created should only provide a pretext for the emotion to expand indefinitely."

At this moment, I was in front of a marble group representing *Pygmalion and His Statue.* The ancient sculptor passionately embraced his work, which came to life in his arms.

Suddenly Rodin said: "I am going to surprise you. I must show you the first sketch for this composition."

Thereupon, he led me to a plaster cast.

I was indeed surprised. The work he showed me had no relation to the tale of Pygmalion. It represented a horned and hairy faun who ardently embraced a panting nymph.[2] The general lines were more or less the same, but the subject was very different.

Rodin seemed amused by my silent astonishment.

For me this revelation was somewhat disconcerting since, contrary to everything I had just seen and heard, my host proved that in certain cases he was indifferent to the subject treated.

He looked at me in an almost mocking way.

"When all is said and done," he told me, "you should not attribute too much importance to the themes you interpret. No doubt, they have their value and help to charm the public, but the main concern of the artist should be to fashion living musculatures. The rest matters little."

Then, suddenly, as if guessing my confusion: "Do not think, my dear Gsell, that my last words contradict those I pronounced earlier.

"If I feel that a sculptor can limit himself to representing palpitating flesh, without bothering with a subject, that does not mean that I exclude thought from his work. If I declare that he need not seek symbols, that does not mean that I favor an art without spiritual significance.

"But, to tell the truth, everything is idea, everything is symbol.

"So the forms and the poses of a human being necessarily reveal the feelings of his soul. The body always expresses the spirit for which it is the shell. And for him who has eyes to see, nudity offers the richest meaning. In the majestic rhythm of the contours, a great sculptor, a Phidias, recognizes the serene harmony diffused throughout Nature by divine Wis-

dom. A simple torso—calm, well-balanced, radiant with strength and grace—can make him think of the all-powerful reason that governs the world.

"A beautiful landscape affects us not only because of the more or less agreeable sensations it provides, but above all because of the ideas it awakens. The lines and the colors observed there are not moving in themselves, but by the profound meaning attached to them. In the silhouette of trees, in the indentation of a horizon, great landscape painters like Ruysdael, Cuyp, Corot, Théodore Rousseau sensed thoughts, smiling or serious, daring or discouraged, peaceful or anguished, that were in tune with the disposition of their spirit.

"This is because the artist who overflows with feeling cannot imagine anything that is not as full of this as he is himself. In all Nature, he surmises a great spirit [*une grande conscience*] similar to his own. There is no living organism, no inert object, no cloud in the sky, no green sprout in the meadow that does not entrust him with the secret of an immense power hidden in all things.

"Look at the masterpieces of art. All their beauty comes from the thought, the purpose that their authors believed they divined in the Universe.

"Why are our Gothic cathedrals so beautiful? It is because in all the representations of life—from the human images that ornament their portals to the crosiers of plants that flourish on their capitals—one discovers the mark of celestial love. Our sweet image-makers of the Middle Ages saw infinite bounty shining everywhere. And in their charming naivety, they have even projected a glimmer of kindness onto the faces of their demons, shown with amiable malice and almost as cousins to the angels.

"Look at any painting by a master, by Titian or Rembrandt, for example.

"In all the lords of Titian, you notice the proud energy that, without any doubt, animated the artist himself. His op-

ulent, nude women allow themselves to be adored like goddesses certain of their domination. His landscapes, studded with majestic trees and glowing with triumphant sunsets, are not less lofty than his figures. He has made aristocratic pride reign in all of creation: this was the constant idea of his genius.

"Another kind of pride lights the wrinkled and sear faces of the old artisans painted by Rembrandt. It ennobles his small smoky garrets and his bottle-glass windows. It illuminates his flat, rustic landscapes with a sudden burst of sunlight. It magnifies the thatched roofs that his engraving tool caressed with delight on the copper plate. In these we see the beautiful valour of modest beings, the holiness of common, but piously loved, things, the grandeur of humility which accepts and fulfills its destiny with dignity.

"The thinking of the great artists is so enduring, so profound, that it is apparent regardless of the subject. They do not even need entire forms to express themselves. Take any fragment of a masterpiece, and you will recognize in it the soul of the author. Compare, if you like, the hands in portraits painted by Titian and Rembrandt. Titian's hand will be domineering; Rembrandt's will be modest and courageous. These tiny fragments of paintings hold the complete ideal of these masters."

I was listening passionately to this beautiful profession of faith in the spirituality of art. But an objection had come to my lips: "Master," I said, "no one doubts that paintings and sculptures can suggest to those who look at them the most profound ideas. But many skeptics maintain that the painters and sculptors never had these ideas themselves and that *we* put them into their works. They believe that artists are purely instinctive, like the Sibyl, who on her tripod pronounced the oracles of the gods without knowing herself what she prophesied.

"Your words clearly prove that with you, at least, the hand is always guided by the mind, but is this so with all the mas-

ters? Did they always think while they were working? Did they always have a precise notion of what their admirers would discover in them?"

"Let us understand each other!" said Rodin, smiling. "There are certain admirers with complicated brains who attribute to artists completely unforeseen intentions. These people do not matter. But be assured that the masters are always fully conscious of what they do."

And nodding his head: "In truth, if these skeptics of whom you speak knew what energy the artist sometimes needs just to translate very feebly what he thinks and feels most strongly, they certainly would have no doubt that what appears lucidly in a painting or in a sculpture had been intended."

A few minutes later he continued: "In short, the purest masterpieces are those where there are no superfluous, inexpressive forms, lines, or colors. In these masterpieces everything, absolutely everything, is resolved into thought and spirit.

"And it may very well be that when the masters interpret Nature according to their ideal, they delude themselves.

"It may be that Nature is governed by a blind Force or by a Will whose purposes our intelligence is incapable of penetrating.

"At least when the artist represents the Universe as he imagines it, he formulates his own dreams. In Nature he celebrates his own soul.

"And doing so, he enriches the soul of humanity.

"Since he colors the material world according to his own spirit, he reveals a thousand nuances of feeling to his ecstatic contemporaries. He makes them discover hitherto unknown riches within themselves. He gives them new reasons to love life and new inner lights to guide them.

"He is, as Dante said of Virgil, 'their guide, their lord, and their master.' "

9

Mystery in Art

One morning, when I had gone to Meudon to see Rodin, I was told in the entrance hall of the house that he was ill and that he was resting in his room.

I was already leaving when a door opened at the top of the stairs, and I heard the master call me.

"Come on up; I would be pleased!"

I hurried to respond to this invitation, and I found Rodin in his robe, his hair uncombed, his feet in slippers, in front of a good wood fire (it was November).

"This is the time of year when I allow myself to be sick," he told me.

"Oh yes! During all the rest of the year, I have so much work, so many occupations, so many worries, that it is totally impossible for me to breathe an instant. But fatigue accumulates, and although I fight obstinately to overcome it, when the end of the year approaches, I am forced to stop my work for a few days."

While receiving these confidences, I looked at the wall where there was a large cross to which was nailed a Christ, three-quarters life-size.

It was a painted sculpture of a very beautiful character. The divine body hung like a sublime rag on the instrument of execution. Its flesh was bruised, bloodless, greenish. The head had dropped and was painfully resigned. A god so dead it seemed he would never be resurrected. The most complete consummation of the mysterious sacrifice.

"You are admiring my crucifix!" Rodin said to me. "It is

prodigious, isn't it? Its realism recalls the one in the chapel of the Santisimo Cristo in Burgos, that image that is so moving, so terrifying—shall we say the word, so horrible—that it is taken for a real corpse that has been stuffed.

"In truth, the Christ here is much less savage. How pure and harmonious are the lines of the body and the arms!"

Seeing my host in ecstasy, I had the idea of asking him if he was religious.

"That depends on what you mean by the word," he answered. "If by religious you mean a man who strongly adheres to certain practices, who bows before certain dogmas, obviously I am not religious. Who is any more in our time? Who is willing to abdicate his critical mind and his reason?

"But, in my opinion, religion is something besides the reciting of a credo. It is the sentiment of everything that is unexplained and no doubt inexplicable in the world. It is the adoration of the unknown Force that maintains the universal laws and that preserves the types of beings. It is the suspicion of whatever in Nature lies beyond our senses, the suspicion of the whole immense domain of things that neither the eyes of our bodies nor even those of our spirits are capable of seeing. Then again, it is the impetus of our soul [*la conscience*] toward infinity, eternity, toward boundless knowledge and love; these are perhaps illusory expectations, but, already in this life, they make our thoughts flutter as if they had wings.

"In this sense, I am religious."

Now Rodin was following the undulating and rapid flames of wood burning in the fireplace.

He continued: "If religion did not exist, I would have felt the need to invent it.

"True artists are, then, the most religious of mortals.

"People believe that we live only by our senses and that the world of appearances is enough for us. People take us for children who become inebriated by iridescent colors and who play with forms as if with dolls. People understand us poorly. Lines and shades are only signs of hidden realities for

us. Beneath the surfaces [of things], our gaze plunges to the spirit, and then when we reproduce contours, we enrich them with the spiritual content they enclose.

"The artist worthy of the name must express the entire truth of Nature, not only the truth of the outside, but also, and above all, that of the inside.

"When a good sculptor models a human torso, he represents not only the muscles but also the life that moves them. He represents even more than the life; he represents the power that formed them and granted them grace, vigor, amorous charm, or the untamed fire.

"Michelangelo makes the creative force thunder in all living flesh. Luca della Robbia makes it smile divinely. So each sculptor, according to his temperament, attributes a tragic or very sweet soul to Nature.

"The landscape painter perhaps goes further. It is not only in animated beings that he perceives the universal soul. It is in the trees, the bushes, the plains, the hills. What to other men is only wood and earth appears to a great landscape painter as the face of an immense being. Corot saw bounty in the trees, the grassy meadows, and the surface of lakes. Millet saw in nature suffering and resignation.

"Everywhere the great artist listens to the spirit answering his own spirit. Where will you find a more religious man?

"Does not the sculptor perform an act of adoration when he perceives the grandiose character of the forms he studies; when he knows how to extract the eternal type of each being from among the momentary lines; when he seems to discern, in the very bosom of the divinity, the immutable models after which all creatures are formed? Look, for instance, at the masterpieces of Egyptian sculpture, either human or animal figures, and tell me whether the emphasis of the essential contours does not produce the troubling effect of a sacred hymn. Every artist who has the gift of generalizing forms, that is to say, of stressing their logic without emptying them of their life, expresses a similar religious emotion. For he

communicates to us the thrill he himself felt in front of immortal truths."

"Something like the trembling of Faust," I said, "visiting that strange realm of Mothers, where he converses with the undying heroines of the great poets and where he contemplates all the generative ideas of terrestrial realities, impassible in their majesty."

"What a magnificent scene," exclaimed Rodin, "and what breadth of vision in Goethe!"

He continued: "Mystery is, moreover, like the atmosphere in which very beautiful works of art bathe.

"They express, in effect, everything that genius feels when confronting Nature. They represent it with all the clarity, with all the magnificence that a human brain is able to discover. But, on the other hand, they inevitably are stopped by the immense Unknowable that completely surrounds the very small sphere of the known. For in the final analysis, we feel and understand only the tips of things presented to us in this world that are able to impress our senses and our souls. But everything else continues into infinite darkness. And even though they are close at hand, a thousand things are hidden because we are not capable of grasping them."

Since Rodin was silent a moment, I contented myself with reciting the verses of Victor Hugo:

> We only see one side of things;
> The other is plunged into the night of a terrifying mystery.
> Man submits to the effect without knowing the causes:
> Whatever he sees is shallow, useless and fleeting.[1]

"The poet has said it better than I," said Rodin smiling.

He continued: "Beautiful works of art, which are the highest testimonies of intelligence and of human sincerity, say everything that one can say about man and about the world. Besides, they make us understand that there is something else that one cannot know.

"Every masterpiece has this mysterious characteristic. One always finds in it a little bewilderment. Remember the question mark that hovers over all the paintings of Leonardo. But I am wrong to choose this great mystic as an example. With him my thesis is verified too easily. Let us take instead the sublime *Concert Champêtre* by Giorgione. This expresses all the sweet joy of life, but to this is added a sort of melancholy inebriation. What is human joy? Where does it come from? Where is it going? The enigma of existence!

"Let us also take, if you like, *The Gleaners* by Millet. One of these women who toils horribly under the torrid sun straightens up and looks at the horizon. And we seem to understand that in this coarse face a question has suddenly become conscious [*la conscience*]: 'What's the use?'[2]

"There lies the mystery that hovers over the whole work.

"What good is the law that chains creatures to existence only to make them suffer? What good is this eternal lure that makes them love life even though it is essentially sad? Anguishing problem!

"It is not only the masterpieces of Christian civilization that produce this mysterious impression. One experiences it also before the masterpieces of antique Art, before the *Three Fates* from the Parthenon, for example. I call them *Fates* because this is the conventional appellation although in the opinion of scholars these statues personify other goddesses. It matters little, anyway! There are only three seated women, but their pose is so serene, so majestic, that they seem to participate in something grand that we do not see. Over them reigns, in effect, the great mystery: immaterial, eternal Reason obeyed by all Nature. The three women are its [Reason's] celestial servants.

"So all the masters reach the private enclosure of the Unknowable. Some of them lamentably bruise their foreheads here. Others, who have a more optimistic imagination, think they hear from behind the wall the songs of melodious birds, who populate the secret orchard."

I listened attentively to my host, who was surrendering to me his most precious thoughts on his art. It seemed that fatigue had sentenced his body to inaction before this fireplace with its dancing flames but had left his mind freer and invited it to launch itself uninhibitedly into dreaming.

I brought the conversation back to his own works.

"Master," I said to him, "you talk about other artists, but you keep quiet about yourself. You are, however, one of those who has put the most mystery into his art. In the least of your sculptures, one recognizes something of the torment of the invisible and the inexplicable."

"What, my dear Gsell!" he said, darting me an ironic look. "If I have translated certain feelings in my works, it is perfectly unnecessary for me to detail them in words, for I am not a poet but a sculptor. And one should be able to read them easily in my sculptures. Otherwise I might as well not have experienced these feelings."

"You are right. It is up to the public to discover them. So I will tell you about the mysteriousness I believe I have observed in your inspiration. You will say if I saw correctly.

"It seems to me that what has preoccupied you above all in the human being is the strange discomfort of the soul bound inside the body; in all your statues it is the same leap of the spirit toward the dream, in spite of the weightiness and cowardliness of the flesh.

"In your *Saint John the Baptist* the heavy and almost crude organism is tensed and seemingly uplifted by a divine mission that surpasses all earthly bounds. In your *Burghers of Calais*, the soul, longing for a sublime immortality, drags the hesitant body to the execution and seems to shout the famous saying, 'You tremble, flesh!' In your *Thinker*, meditation, which desires in vain to embrace the absolute, contracts the athletic body under its terrible effort, bends it, curls it up, crushes it. Even in your *Kiss*, the bodies quiver anxiously as if they feel in advance the impossibility of realizing the indissoluble union desired by their souls. In your *Balzac*, ge-

nius, haunted by gigantic visions, tosses the ailing body about like a rag, forces it to insomnia, and condemns it to forced labor.

"Is all this right, master?"

"I will not say no," said Rodin, who pensively caressed his long beard.

"And in your busts you have perhaps shown even more of this impatience of the spirit with the chains of matter.

"Almost all recall the beautiful verse by the poet:

> Just as the bird in taking flight bends the branch,
> So his soul has broken his body![3]

"You have represented writers with heads bowed as if by the weight of their thoughts. As for your portraits of artists, they stare straight before them at Nature, but they are haggard because their dreams lead them far beyond what they see, far beyond what they can express!

"That bust of a woman at the Musée du Luxembourg, perhaps the most beautiful one you have sculpted, leans and wavers, as if the soul felt dizzy upon plunging into the abyss of dream.[4]

"And, finally, your busts have often reminded me of the portraits by Rembrandt. For the Dutch master has also made visible this call of the infinite by lighting the forehead of his personages with a light that falls from above."

"Compare me with Rembrandt! What sacrilege!" Rodin cried sharply. "With Rembrandt, the colossus of Art! What are you thinking of, my friend! We should prostrate ourselves before Rembrandt and never compare anyone with him!

"But, in observing my works, you have correctly put your finger on the leap of the soul toward the perhaps chimerical realm of truth and of boundless liberty. There lies, indeed, the mystery that moves me."

A moment later he asked me:

"Are you convinced now that Art is a kind of religion?"

"Without doubt," I answered.

Then, mischievously, he said: "It is important, however, to remember that the first commandment of this religion for those who want to practice it is to model well an arm, a torso, or a thigh!"

10

Phidias and Michelangelo

One Saturday evening Rodin said to me: "Come and see me tomorrow morning at Meudon; we will talk about Phidias and Michelangelo, and I will model statuettes according to the principles of each artist before your eyes. In this way, you will grasp perfectly the essential differences in their inspirations or, rather, the complete opposition that separates them."

Phidias and Michelangelo commented upon and evaluated by Rodin! You can imagine I was prompt for our meeting.

The master installed himself before a marble table and had clay brought to him. It was still winter, and the large studio was not heated. I confided to a practitioner[1] my fear that my host would catch a cold. "Oh! never when he is working," he responded, smiling.

Indeed, the master immediately began to model the clay so feverishly that I was completely reassured.

He invited me to sit beside him, and rolling the clay into sausages on the table, he used these to rapidly shape a sketch.

At the same time, he talked.

"I will make this first figure," he said to me, "according to the conception of Phidias.

"When I say this name, I really think of all Greek sculpture; the genius of Phidias was its highest expression."

The clay figure was taking shape. Rodin's hands were moving to and fro, superimposing bits of clay, moulding them in his large palms without any loss of movement. Then his thumb and his fingers played their part, forming a thigh

with a single squeeze, making a hip stick out, tilting a shoulder, turning the head; he did all this with incredible speed as if he were performing an act of prestidigitation. Sometimes the master would stop a moment to look at his work, reflect, make a decision, and suddenly execute his resolution at full speed.

I have never seen anyone work so fast. Evidently sureness of mind and eye endow the hands of great artists with an ease comparable to the skill of the most marvelous jugglers. Or if we want to compare this to a more glorious profession, then we can compare it to the skill of the best surgeons. Moreover, this facility, far from excluding precision and forcefulness, on the contrary, includes them. Consequently, it has nothing to do with empty virtuosity.

Now, Rodin's statuette was alive. It was delightfully rhythmic. One fist was on the hip, the other arm fell gracefully along the thigh. The head was bent lovingly.

"I am not conceited enough to believe that this sketch is as beautiful as the antique," the master said laughing, "but don't you find that it gives a remote idea of it?"

"One would swear it is a copy of a Greek marble," I answered.

"Well, let's examine the reason for this resemblance. From head to foot my statuette offers four planes alternately opposed.

"The plane of the shoulders and thorax recedes to the left, the plane of the abdomen to the right. The plane of the knees recedes to the left since the knee of the bent right leg is in front of the left leg. Finally, the right foot is behind the left.

"So, I repeat, you can note four directions in my figure. These produce a very soft undulation throughout the body.

"This impression of tranquil charm is also a result of the equilibrium of the figure. The axis drawn from the middle of the neck will fall on the bony protuberance on the inside of the ankle[2] of the left foot, which carries the entire weight of the body. The other leg, on the contrary, is free. Only the

tips of the toes touch the ground, and so these provide only additional support. If necessary, the right leg could be lifted without jeopardizing the balance. This is a posture full of freedom and grace.

"Another observation can be made. The upper part of the torso bends to the same side as the leg that supports the body. So the left shoulder is at a lower level than the other. In opposition, the left hip is raised and protrudes; the entire thrust of the stance is directed here. So, on the left side of the torso, the shoulder moves toward the hip. On the other side, the right shoulder, which is raised, moves away from the right hip, which is lowered. This recalls the movement of an accordion; when compressed on one side, it stretches on the other.

"This tilting of both shoulders and hips [*double balancement*] contributes further to the serene elegance of the whole.

"Now look at my statuette in profile.

"It is arched behind, the back incurved and the thorax lightly bulging upward. It is convex, in a word, and takes the shape of the letter 'C.'

"Because of this configuration, the figure receives full light. The light is softly distributed over the torso and the limbs, thus adding to the general attractiveness.

"Now, the various characteristics that we have noticed in this sketch can be found in almost all antique statues. No doubt, there are numerous variants. No doubt, there are even some deviations from the fundamental principles. But you will always find most of the characteristics I have indicated in Greek works.

"Translate this technical system into spiritual language; you will then realize that antique art signifies joy of life, quietude, grace, balance, reason."

Rodin's eyes swept over his statuette.

"One could," he said, "finish it, but this would be only for amusement. It suffices for my demonstration as it is.

"Anyway, the details would add little. And here, by the way, we have an important truth. When the planes of a figure are placed well, with intelligence and resolve, all is done, so to speak. The total effect has been achieved. The finicking that comes next may please the spectator, but it is almost superfluous. This science of the planes is common to all the great periods; it is almost ignored today."

Having said this, he pushed his clay sketch aside.

"Now, I'm going to make another statuette according to the conception of Michelangelo."

He did not proceed at all as he had with the first.

He twisted both legs of his figure to one side and the body to the other. He bent the torso forward. He folded one arm and glued it to the body. The other he brought back behind the head.

This suggested attitude offered a strange impression of effort and torture.

Rodin had fashioned this sketch as quickly as the first one, but he pressed the pellets of clay on even more nervously and modeled with his thumbs more frantically.

"There it is!" he said. "How does it look to you?"

"One would really believe this to be an imitation of Michelangelo or rather a replica of one of his works. What vigor! What tension in the muscles!"

"Very well! Do follow my explanation. Here, instead of four planes, there are only two: one for the upper part of the statuette and another, moving in opposition, for the lower part. This creates a gesture that is at once violent and constrained. This results in a striking contrast with the calm of ancient figures.

"The two legs are bent, and consequently the weight of the body is shared by both legs rather than being carried exclusively by one. So the two lower limbs do not rest, but rather they exert themselves.

"Furthermore, the hip corresponding to the leg that sup-

ports the least weight is pushed out and elevated the most, indicating that the body is being thrust in this direction.

"The torso is no less animated. Instead of dropping gently toward the projecting hip, as in antique figures, the shoulder is raised on the same side as the raised hip in order to continue the movement.

"Notice also that the concentration of the effort causes the two legs to press against one another and the two arms to press against the body and the head. So any void between the limbs and the trunk disappears. No longer do you see those open spaces resulting from the free disposition of arms and legs; the presence of such voids in Greek sculpture makes it lighter. Michelangelo created statues as they emerged, as a block. He himself used to say that only those works that could be rolled from the top of a mountain without breaking anything were good. In his opinion, anything broken off in such a fall was superfluous.

"Certainly, his figures seem to have been carved to meet this test. But it is also certain that no antique work would have passed it. The most beautiful works of Phidias, Polykleitos, Scopas, Praxiteles, and Lysippus would have arrived at the bottom of the hill in pieces.

"And here you see how a maxim that is true and profound for one artistic school is false for another.

"A final very important characteristic of my sketch is that it is in the shape of a console: the knees constitute the lower bulge, the incurved thorax makes the concavity, and the bent head is the upper projection of the console. So the torso is bent forward whereas it was bent backward in antique art. In my sketch this shape results in very deep shadows in the hollow of the chest and under the legs.

"In short, the most powerful genius of modern times celebrated the epic of shadow, the ancients that of light.

"Now let us seek, as we did with the Greeks, the spiritual meaning of the technique of Michelangelo. We notice that

his sculpture expresses the painful withdrawal of the being into himself, restless energy, the will to act without hope of success, and finally the martyrdom of the creature who is tormented by his unrealizable aspirations.

"You know that Raphael during one period of his life sought to imitate Michelangelo. He did not succeed. He could not discover the secret of the condensed power of his rival. This is because Raphael was formed by the Greek school. His divine trio of Graces at Chantilly, which was based on an adorable antique group in Siena, proves this. Unconsciously, he constantly went back to the principles of his preferred masters. Even the most vigorous of his figures always have this rhythm and gracious counterbalance of the Hellenic masterpieces.

"When I went to Italy myself, I was disconcerted before the works of Michelangelo since I had my mind full of the Greek models I had studied passionately at the Louvre.[3] At every turn, Michelangelo's figures contradicted the truths I thought I had finally acquired. 'Well!' I said to myself, 'why this incurvation of the torso? Why this raised hip? Why this lowered shoulder?' I was quite confused.

"However, Michelangelo could not have been mistaken! I had to understand. I applied myself to this and I succeeded.

"To tell the truth, Michelangelo is not, as is often claimed, an isolated figure in art. He is the result of all Gothic thought. It is usually said that the Renaissance was the resurrection of pagan rationalism and its victory over the mysticism of the Middle Ages. This is only half true. The Christian spirit continued to inspire a good number of Renaissance artists, among them Donatello, the painter Ghirlandaio, who was the master of Michelangelo, and Buonarroti himself.

"Michelangelo is clearly the heir of the image-makers of the thirteenth and fourteenth centuries. You constantly rediscover in medieval sculpture that console shape that I have just pointed out to you. You rediscover that incurvation of

the thorax, those limbs flattened against the torso, and that attitude of effort. Above all, you rediscover a melancholy attitude that views life as temporary, something to which you should not attach yourself."

As I was thanking my host for his precious lesson, he said to me: "We must complete it one of these days with a visit to the Louvre. Don't forget to remind me of this promise."

At this moment, a servant introduced Anatole France, whose visit Rodin was awaiting. For the master sculptor had invited the great writer to come and admire his collection of antique art.

I really congratulated myself, as you can imagine, for being present at this interview between two men who bring so much honor to our nation today.

They hastened toward each other with that mutual deference and that affable modesty which true merit always displays in the presence of an equal. They had already met at friends' houses, but they had never spent several hours together as they did that day.

Together they formed a kind of antithesis.

Anatole France was tall and thin. He had a long and fine face. His malicious black eyes hid at the back of their sockets. He had delicate and tapering hands. His gestures underlined with vivacity and precision the play of his irony.

Rodin was stocky. He had broad shoulders. His face was full. His dreamy eyes, often half-closed, sometimes opened wide and revealed very light blue irises. His thick beard made him look like one of Michelangelo's prophets. He moved slowly, gravely. His huge hands with short fingers had a robust suppleness.

One was the personification of profound and witty analysis, the other of boldness and passion.

The sculptor led us before the antiques that he possessed, and the conversation naturally returned to the subject he had just treated with me.

A Greek stele provoked the admiration of Anatole France. It showed a seated young woman regarded lovingly by a man; behind her, a servant bent over her shoulder.

"How these Greeks loved life," exclaimed the author of *Thaïs*.

"Look! Nothing reminds us of death on this funerary stone. The deceased woman remains among the living and seems to still participate in their existence. She merely became very weak; since she can no longer support herself, she must remain seated. This is one of the characteristics that usually identify dead people on antique steles. Since their legs lack strength, they must lean on a staff or against a wall, or they must sit down.

"There is yet another detail that frequently distinguishes the dead. Whereas the living personages represented around the dead look at them tenderly, the dead allow their eyes to wander vaguely and fix them on no one. They do not see those who see them. They continue, nevertheless, to live among those who cherish them like much beloved invalids. This half-presence, half-absence is the most touching expression of the longing that daylight inspires in dead souls, according to the Ancients."

We inspected many other antiques. Rodin's collection is large and select. He was especially proud of a Hercules whose vigorous slenderness filled us with enthusiasm. This statue does not resemble the heavy Hercules Farnese at all. It is marvelously elegant. The demi-god, in all his proud youth, has a torso and limbs of extreme delicacy.

"This is the way the hero who ran down the hind with bronze feet really is," our host told us. "The weighty athlete of Lysippus would not have been capable of such prowess. Strength is often allied with grace, and true grace is strong; this *Hercules* bears witness to this double truth. As you see, the son of Alceme looks, in effect, all the more robust when his body is more harmoniously proportioned."

Anatole France stopped for a long time before a charming little torso of a goddess.

"It is," he said, "one of the countless examples of the *Aphrodite pudica* type, which in antiquity follows, more or less freely, Praxiteles's masterpiece, the *Cnidian Venus*. The Capitoline and Medici Venuses, among others, are only variations of that model that was copied so many times.

"With the Greeks, many excellent sculptors took great care to imitate the work of a master who had preceded them. They modified the general motif only slightly and revealed their own personality only in the execution.

"In fact, it seems that it was the devotion attached to a sculpted image that prohibited artists from altering it. Religion fixes the divine types it adopts once and for all. We are surprised to find so many of the *Venus pudica* and the crouching Venus types; we forget that these statues were sacred. Similarly, in a thousand or two thousand years there will be rediscovered many statuettes of the Virgin of Lourdes, all very similar, with a white robe, a rosary, and a blue belt."

"How sweet," I exclaimed, "was this Greek religion which offered such voluptuous forms to the adoration of the faithful!"

"It was beautiful," Anatole France resumed, "since it bequeathed to us such seductive Venuses, but do not believe that it was sweet. It was intolerant and tyrannical like any pious fervor.

"In the name of the Aphrodites with quivering flesh, many noble spirits were tormented. In the name of Olympus, the Athenians handed Socrates the cup of hemlock. And remember the line by Lucretius: *Tantum religio potuit suadere malorum!*[4]

"You see, if the gods of antiquity seem likable to us today, it is because, being dethroned, they can no longer do evil."

It was noon, and Rodin invited us to go into the dining room; we left his beautiful collection with regret.

At the Louvre

Some days later, Rodin kept his promise to me and invited me to accompany him to the Musée du Louvre.

As soon as we were before the ancient sculptures, he took on a happy air, as if he found himself once again among old friends.

"How many times," he told me, "I came here in the past when I was only about fifteen years old. At first I had a violent desire to be a painter. Color attracted me. I often went upstairs to admire the Titians and the Rembrandts. But alas, I didn't have enough money to buy canvases and tubes of paint. To copy ancient sculpture, on the other hand, I only needed paper and pencils. So I was forced to work only in the ground-floor rooms, and soon I developed such a passion for sculpture that I thought of nothing else."

Listening to Rodin tell me in this way about the studies he made after the antique, I thought about the injustice of the pseudo-classicists who accused him of rebelling against tradition. It is this alleged revolutionary who, today, knows tradition best and respects it most!

He led me into the room with casts, and pointing out the *Diadoumenos* by Polykleitos, made from the marble in the British Museum, he told me:

"Here you can observe the four directions that I indicated the other day in my clay sketch. Look at the left side of this statue; the shoulder is slightly forward, the hip back, the knee again forward, and the foot back. This results in the soft undulation of the whole.

"Now, notice the counterbalancing of the lines; the shoulder line tilts to the right, the hip line tilts to the left. Note the axis that passes through the middle of the neck and falls on the malleolus internus of the right foot. Notice the unengaged position of the left leg.

"Finally, notice in the profile view how the front of the statue is convex; it has the shape of a 'C.'"

This first example alone convinced me, but Rodin repeated his demonstration with many other antique sculptures.

Leaving the casts, he led me to the divine torso of the *Periboetos* by Praxiteles.

"The shoulders go back to the left, the hips to the right. The right shoulder and the left hip are both raised."

Yielding to less theoretical impressions he said: "What elegance! This young, headless torso seems to smile better than eyes or lips at the light and at spring."

Then, in front of the *Venus de Milo*: "Here is the marvel of marvels! It has an exquisite rhythm very similar to that of the statues we have just admired, but in addition there is something pensive. For here we no longer find the 'C' shape; on the contrary, the torso of this goddess leans slightly forward like Christian statues. However, there is nothing restless or tormented. The work displays the most beautiful antique inspiration. It is pleasure regulated by restraint. It is the joy of life measured, tempered by reason.[5]

"These masterpieces produce a strange effect on me. They naturally revive in my thoughts the atmosphere and the country where they were born.

"I see the Greek youths with their dark hair crowned by violets and the virgins in floating tunics offering sacrifices to the gods in those temples of pure and majestic lines, of marble the warm transparency of flesh. I imagine philosophers walking on the outskirts of a city and talking about Beauty near an old altar that reminded them of a terrestrial adventure of some god. Meanwhile, the birds sing beneath the ivy, in the large plane trees, in the laurel and myrtle bushes, and the streams sparkle beneath the sky, serene cover for this sensual and peaceful nature."

A few instants later, we were before the *Victory of Samothrace*.

"In your imagination, place this back on a beautiful golden shore from which you can see, under the branches of olive trees, the glittering sea with its white islands in the distance!

"Antique works need full light. In our museums, they are laden with shadows that are too strong. The reflection from the sunlit Earth and the nearby Mediterranean surrounded them with a dazzling and splendid aureole.

"Their *Victory* was their *Liberty*. How different it was from ours!

"She did not hoist her skirt to jump over barricades.[6] She was dressed in very light linen, not in heavy wool. Her body, marvelously beautiful, was not made for everyday tasks. Her movements, although vigorous, were always harmoniously balanced.

"In truth, she was not Liberty for all men, but only for distinguished minds.

"Philosophers contemplated her ecstatically. But the vanquished, the slaves she had beaten, could not have felt tenderness for her.

"There is the defect of the Hellenic ideal.

"The beauty conceived by the Greeks was Order as dreamed by Intelligence; consequently, it addressed only very cultivated minds. It disdained humble souls. It had no pity for the good will of unsophisticated beings and did not know that there is in each heart a bit of heaven.

"Beauty tyrannized anything that was not capable of elevated thought. It inspired Aristotle's apology of slavery. It only acknowledged the perfection of forms, and it was unaware that the expression of a homely creature can be sublime. It was responsible for deformed children being cruelly thrown into a pit.

"This same order, which was exalted by the philosophers, offered something too fixed. They imagined it according to their desires and not as it exists in the vast Universe. They arranged it according to their human geometry. They believed the world was limited by a great crystal sphere. They feared

the undefined. They also feared progress. According to
them, creation was never so beautiful as at its dawn, when
nothing had yet troubled its primitive equilibrium. Since
that time, everything had become worse. A little confusion
was introduced each day in the universal order. The golden
age, which we glimpse on the horizon of the future, they
placed far behind them in the beginning of time.

"So their passion for good order deceived them. No
doubt, order reigns throughout all nature, but it was much
more complex than man could imagine it in the first efforts
of his reason. Besides, it is eternally changing.

"However, sculpture was never more radiant than when it
was inspired by this strict order. This is because calm beauty
expressed itself entirely in the serenity of diaphanous mar-
bles. This is because there was perfect harmony between
thought and matter animated by thought. The modern
spirit, to the contrary, disrupts and shatters all the forms in
which it is incarnated.

"No, no artist will ever surpass Phidias. For progress exists
in the world, but not in art. The greatest of the sculptors,
who appeared at the time when the entire human dream
could be contained in the pediment of a temple, will never be
equaled."

We then proceeded to the Michelangelo room.

To get there we walked through the Jean Goujon and Ger-
main Pilon room.

"Your big brothers," I said to Rodin.

"I wish this were so," he said with a sigh.

Now we were in front of the *Captives* of Buonarroti.

We first looked at the one on the right, which was shown
in profile.

"Look, only two broad directions! The legs to one side, the
torso to the other. This gives the pose an extreme forceful-
ness. No counterbalancing of the lines. Both the right hip
and the right shoulder are raised. This intensifies the move-
ment. Let us observe the axis. It no longer falls on one foot,

but between the two feet. So the two legs equally support the torso and seem to exert themselves.

"Let us finally consider the general appearance. It is like a console: the bent legs make, in effect, a projection, and the contracted thorax forms a depression.

"This confirms what I showed you in my studio in the clay sketch."

Then, turning toward the other *Captive*, he continued: "Here the console shape is brought out not by the depression of the chest, but by the raised elbow which hangs forward.

"This very peculiar silhouette, as I have told you, is that of all medieval statues.

"The seated Virgin who leans toward her child forms a console. So does Christ nailed to the cross, his legs bent, his torso leaning toward the men who will be redeemed by his suffering. So does the *Mater dolorosa* who bends over the corpse of her son.

"Michelangelo, once again, is the last and greatest of the Gothics.

"The soul thrown back upon itself, suffering, the disgust for life, the fight against the chains of matter, these are the elements of his inspiration.

"His *Captives* are held by bonds so weak that it would seem easy to break them. But the sculptor wanted to show that their detainment is, above all, spiritual. For although he has represented in these figures the provinces conquered by Pope Julius II, he has given them a symbolic value. Each of his prisoners is the human soul that would like to break out of the cope of its corporeal envelope in order to possess boundless liberty.

"Look at the *Captive* on the right. He has the face of Beethoven. Michelangelo has foretold the features of the most anguished of the great musicians.

"His entire life demonstrates that he himself was terribly tortured by melancholy. 'Why does one long for more life and pleasure,' he said in one of his beautiful sonnets. 'The more terrestrial joy seduces us, the more it harms us.'

"And in another fragment of verse: 'He enjoys the best fate whose death closely follows his birth.'

"All his statues show such an agonizing strain that they seem to want to break themselves. All seem about to give way to the overpowering pressure of despair that lives in them. When Buonarroti was old, he actually broke them. Art no longer satisfied him. He longed for the infinite. 'Neither painting nor sculpture,' he wrote, 'will any longer charm the soul turned toward this divine love who opens his arms on the cross to receive us.'

"These are the exact words of the great mystic who composed the *Imitation of Jesus Christ*: 'Sovereign wisdom strains for the realm of heaven through its contempt for the world. Vanity to attach yourself to what passes so fast and not to hasten toward the joy that never ends.' "

Rodin then digressed in the middle of his thoughts: "I remember being in the Cathedral in Florence and looking at Michelangelo's *Pietà* with profound emotion. This masterpiece, ordinarily in shadow, was at this moment lit by a tall silver candlestick. A young altar boy of perfect beauty approached the candlestick, which was the same height as he, pulled it near his mouth, and blew out the flame. Then, I no longer saw the marvelous sculpture. This child seemed to me to represent the genius of Death who extinguishes Life. I have preciously guarded this striking image in my heart.

"If I'm allowed to talk a little about myself," he continued, "I will tell you that I have always vacillated between the two great tendencies in sculpture, between the conception of Phidias and that of Michelangelo.

"I started with the Antique, but when I went to Italy, I suddenly fell in love with the great Florentine master, and my works have certainly felt the effects of this passion.

"Since then, above all in recent years, I have come back to the Antique.

"The favorite themes of Michelangelo—the depth of the human soul, the holiness of exertion and suffering—have an austere grandeur.

"But I do not approve of his contempt for life.

"Earthly activity, as imperfect as it may be, is still beautiful and good.

"Let us love life for the very effort that one can deploy in it.

"As for me, I am trying incessantly to render more calmly my vision of nature. We must strive toward serenity. There will always be in us enough Christian anxiety when confronted with mystery."

11

The Usefulness of Artists

I

On the eve of the opening day, I met Auguste Rodin at the Salon de la Société Nationale.[1] I was accompanied by two of his pupils, now masters themselves: the excellent sculptor Bourdelle, who exhibited this year a fierce Heracles shooting with his arrows the birds of Lake Stymphalus, and Despiau, who models busts of an exquisite subtlety.

All three of them stopped before an image of the god Pan, which Bourdelle with his artist's fancy had sculpted to resemble Rodin. The author of this work apologized for having placed two little horns on the forehead of his master. And Rodin, laughing, said:

"You had to since you are representing Pan. Besides, Michelangelo has given similar horns to his Moses. They are the emblem of the all-powerful and the all-wise, and I am surely very flattered to have been granted it by you."

Since it was noon, the master invited us to have lunch at a restaurant in the neighborhood.

We went out. We were on the Champs-Elysées.

Under the young acid green of the chestnut trees, the autos and the horse-drawn carriages glided by in glistening lines. This was the sparkle of Parisian luxury in its most luminous and most fascinating aspect.

"Where are we going to have lunch?" Bourdelle asked with comic anxiety. "In the restaurants of this area, you are generally served by a maître d' in tails, and this is something

I cannot stand since these people intimidate me. In my opinion, we need some good coachman's hangout."

Then Despiau: "You eat better there, in fact, than in sumptuous houses where the dishes are sophisticated. And this is Bourdelle's secret, for his pretended modesty of taste is in reality the love of good food."

Rodin, conciliatory, allowed himself to be led by them to a little eating place that was hidden in a street near the Champs-Elysées. There we chose a cosy corner where we installed ourselves to our liking.

Despiau had a playful and teasing temperament. He said to Bourdelle, while passing him a dish: "Serve yourself, Bourdelle, although you do not deserve to be fed since you are an artist, that is to say, a good-for-nothing."

"I forgive you this impertinence," said Bourdelle, "since you yourself are entitled to half of it."

No doubt he was going through a momentary crisis of pessimism since he added: "Besides, I think you are right. It is really true that we are good-for-nothing.

"When I remember my father who was a pit sawyer, I tell myself, he did a task necessary to society. He prepared the material used in building men's houses. I see him again, my good old man, conscientiously sawing his freestones, winter and summer in the open-air building yard. He was a hard worker, something seldom seen anymore.

"But I—we—what services do we render to our fellow man? We are jugglers, tumblers, fantastic creatures, who amuse the public in street fairs. Hardly ever does anyone condescend to interest himself in our efforts. Few people are able to understand them. And I do not know if we are worthy of their favor since the world can very well do without us."

II

At that, Rodin said: "I imagine our Bourdelle does not believe a word he says. As for me, I have an entirely different

opinion from what he has just expressed. I believe that artists are the most useful of men."

And Bourdelle began to laugh: "This is because the love of your profession makes you blind."

"Not at all. Because my judgment rests on very solid reasons, which I could pass on to you."

"Master, I would greatly like to know them."

"Take then a little of this burgundy that the owner of this place recommended. It will put you in a better disposition to listen to me."

And when he had poured us something to drink, he said: "A first remark. Have you noticed that in modern society, artists, I mean true artists, are almost the only men who practice their trade with pleasure?"

"Certainly," exclaimed Bourdelle, "work is all our joy, all our life, but this does not mean that . . ."

"Wait! It seems to me that what our contemporaries lack most is love for their profession. They do their tasks only with repugnance. They 'sabotage' it gladly. It is the same from the top to the bottom of the social ladder. Politicians look at their duties only in terms of the material advantages they can gain, and they seem to be unaware of the satisfaction that the great statesmen of former times felt when they dealt skillfully with the affairs of their country.

"Industrialists, instead of upholding the reputation of their trademark, try only to earn as much money as they can by debasing their products. Workmen, incited against their employers by a more or less legitimate hostility, botch their work. Almost all the men of today seem to consider work as a ghastly necessity, as a damnable drudgery, when they ought to regard it as their reason for being and their happiness.

"Do not believe, on the other hand, that this was always the case. Most of the objects that have come down to us from the time before the revolution—furniture, utensils, fabrics— denote the great conscientiousness of those who made them.

"Man would just as soon work well as work poorly. I even

believe that the former pleases him more since it is more consonant with his nature. But sometimes he listens to good advice, sometimes to bad. Today he gives preference to bad advice.

"And yet how much happier would humanity be, if work, instead of being the price for existence, were its goal!

"For this marvelous change to occur, all that would be needed would be for all men to follow the example of artists, or rather that they all become artists themselves. For the word in its broadest meaning signifies for me those who take pleasure in what they do. It would be desirable that there be artists in all professions: artist-carpenters, happy to skillfully adjust tenons and mortises; artist-masons, mixing plaster with love; artist-carters, proud of treating their horses well and not running over pedestrians. Wouldn't this create an admirable society?

"So you see the lesson given by artists to other men could be marvelously fruitful."

"Well argued," said Despiau. "I take back what I said, Bourdelle, and I admit that you deserve your food. Have some asparagus, I beg you."

III

Then I addressed myself to Rodin: "Master, you have, without any doubt, the gift of persuasion.

"But, when all is said and done, what is the point of proving the usefulness of artists? Certainly, as you have just shown, their passion for work could be a beneficial example. But the work itself that they execute, is it not fundamentally useless, and is this not precisely what gives it value in our eyes?"

"What do you mean by this?"

"I mean that, very happily, works of art are not counted among useful things, that is to say, among those that serve to feed, dress, shelter us, that is to say, to satisfy our bodily

needs. For, quite to the contrary, they release us from the bondage of practical life and open up the enchanted world of contemplation and dreams."

"My dear friend, people are usually mistaken about what is useful and what is not.

"If we call useful that which responds to the necessities of our material life, I agree with you.

"Today, however, riches displayed only out of petty pride and to excite envy are also considered useful. And these riches are not only useless, they are encumbering.

"As for me, I call useful anything that gives us happiness. Now there is nothing in the world that makes us happier than contemplation and dreaming. This is forgotten too often nowadays. The man free from want, who enjoys, like a sage, the innumerable marvels that meet his eyes and mind at each moment, walks on the earth like a god. He becomes intoxicated admiring the beautiful beings full of vigor who display their quivering fire around him. These are proud samples of the human and animal species—young muscles in movement, admirable living machines, supple, slim, and vigorous. He carries his joy into the vales and hills where spring displays itself in prodigious green and flowery celebrations, effluvia of incense, buzzing bees, rustling wings, and love songs. He becomes ecstatic over the silver ripples that chase one another and seem to smile on the surface of rivers. He becomes enthusiastic when he observes the attempts of Apollo, the golden god, to disperse the clouds that the earth in springtime throws up between herself and him, like a modest lover who hesitates to unveil herself.

"What mortal is more fortunate than this? And since it is art that teaches us, that helps us to taste these joys, who will deny that it is infinitely useful?

"But it is not only a question of intellectual pleasures. Much more is at stake. Art indicates to men their reason for being. It reveals to them the meaning of life; it illuminates their destiny and consequently orients them in life.

"When Titian painted a marvelously aristocratic society

where each personage had written on his face, imprinted in his gestures, and noted in his costume the pride of intelligence, of authority, and of wealth, he offered to the patricians of Venice the ideal they would like to have realized.

"When Poussin composed landscapes where Reason seems to reign, so clear and majestic is the arrangement; when Puget enlarged the muscles of his heroes; when Watteau sheltered his charming and melancholy lovers in mysterious shadows; when Houdon made Voltaire smile and the hunting Diana run lightly; when Rude, in sculpting his *Marseillaise*, called old men and children to support their country; one after the other these great French masters polished some of the facets of our national soul. This one order, this one energy, this one elegance, this one spirit, this one heroism. All the joy of living and acting freely. They perpetuated the distinctive qualities of our ancestry for their compatriots.

"Has not Puvis de Chavannes, the greatest artist of our time, endeavored to dispense the sweet serenity to which we all aspire? His sublime landscapes—where sacred Nature seems to rock in her bosom a humanity that is loving, wise, august, and simple at the same time—are these not for us admirable lessons? Assistance for the weak, love of work, devotion, respect for elevated thought. He has expressed it all, this incomparable genius! It is a marvelous light on our period. It suffices to look at one of his masterpieces—his *Sainte Geneviève*, his *Sacred Wood* at the Sorbonne, or else his magnificent *Homage to Victor Hugo* in the staircase of the City Hall in Paris—to feel capable of noble actions.

"Artists and thinkers are like lyres, infinitely delicate and sonorous. The circumstances of each period set up vibrations in the artists that are continued in all other mortals.

"No doubt men capable of appreciating very beautiful works of art are rare, and, what is more, art is looked at by a limited number of spectators in museums and even in public places. But the feelings they contain, nonetheless, end up infiltrating the masses. Below the geniuses, in fact, are other

artists of lesser talent who pick up and popularize the conceptions of the masters. Writers are influenced by painters as painters are influenced by writers. There is a continual exchange of ideas between all the minds of a generation. Journalists, popular novelists, illustrators, and cartoonists adapt the truths discovered by the powerful intellects for the multitude. It is like a spiritual flood, like a gush that pours into multiple cascades until it forms the great moving sheet of water that stands for the mentality of a period.

"And one should not say, as people usually do, that artists reflect only the feelings of their milieu. This would already be a great deal. For it is not inappropriate to hold up a mirror to other men in order to help them to know themselves. But artists do more. Certainly, they freely borrow from the common sources amassed by tradition, but they also enhance this treasure. They are truly inventors and guides.

"In order to be convinced of this, it suffices to observe that most of the masters lived before, and sometimes much before, the time when their inspirations triumphed. Poussin painted many masterpieces under Louis XIII, whose methodical nobility presaged the character of the following reign. Watteau, whose casual grace seems to have presided throughout the reign of Louis XV, did not live under this king but under Louis XIV, and he died under the Regent. Chardin and Greuze, whose celebration of the bourgeois home seems to announce a democratic society, lived during the monarchy. Proudhon, mystical, sweet, and weary in the middle of strident imperial fanfare, claimed the right to love, to meditate, to dream, and he asserted himself as the precursor of the Romantics. Closer to us, did not Courbet and Millet evoke, during the Second Empire, the toils and the dignity of the lower class, which, since that time during the Third Republic, has won such a preponderant place in society?

"I am not saying that these artists determined the great currents in which one perceives their spirit. I am saying only that they unconsciously contributed to shaping them. I am saying

that they were part of the intellectual elite who created these tendencies. And, of course, this elite is not composed of artists alone but also of writers, philosophers, novelists, and journalists.

"Something else that proves that the masters brought to their generation new ideas and attitudes is the fact that they often had great difficulty in having them accepted. Sometimes they spent almost all their lives fighting routine. The greater their genius, the more likely they are to be misunderstood for a long time. Corot, Courbet, Millet, Puvis de Chavannes, to cite only a few, were unanimously acclaimed only at the end of their careers.

"One does not do good for men with impunity. At least, because of this insistence on enriching the human soul, the masters of Art deserve to have their names held sacred after their death.

"Here you have, my friends, what I wanted to tell you about the usefulness of artists."

IV

I declared that I was convinced.

"I was only asking to be convinced," said Bourdelle in his turn, "for I adore my profession, and my quip a moment ago was probably stirred up by some passing melancholy. Or, rather, desirous of hearing the apology for my profession, I acted like those coquettish women who complain of being ugly in order to provoke compliments."

There were a few moments of silence since we were thinking about what had just been said. Our appetites, however, were not lost, and our forks did wonders during this respite.

Then I ventured to tell Rodin that he had modestly forgotten himself when pointing out the spiritual influence of the masters: "You yourself will have exerted on your period

an influence that, certainly, will be continued by the generations to come.

"By celebrating our interior life with so much force, you will have helped the evolution of modern life.

"You have shown the immense value that each of us today attaches to his thoughts, his loves, his dreams, and often to his follies that are caused by passion. You have recorded the amorous ecstasies, the virginal reveries, the furies of desire, the dizziness of meditation, the impulses of hope, the crises of depression.

"Endlessly, you have explored the mysterious domain of the individual psyche [*la conscience*], and you have found it ever more vast.

"You have observed that in the era we are entering nothing is as important to us as our own feelings, our own intimate self. You have seen that each of us—the thoughtful man, the active man, the mother, the young girl, the lover—has made his soul the center of the universe. And this disposition, which was almost unconscious, you have revealed to us.

"In the footsteps of Victor Hugo—who magnified in poetry the joys and sorrows of private life and celebrated the mother next to the cradle of her child, the father at the tomb of his daughter, the lover before his memories of happiness—you have expressed in sculpture the most profound, the most secret emotions of the soul.

"No doubt this powerful wave of individualism that passes over the old society will modify it little by little. No doubt, thanks to the efforts of great artists and great thinkers who invite each of us to consider himself a self-sufficient goal and to live according to his heart, humanity will finally get rid of all the tyrannies that still restrain the individual and suppress the social inequalities that enslave people, the poor to the rich, the woman to the man, the weak to the strong.

"Because of the sincerity of your art, you will have worked hard toward the progressive advent of this new order."

Then Bourdelle said: "Never has anyone spoken more justly."

But Rodin said with a smile: "Your great friendship grants me too high a place among the champions of modern thought.

"It is true, nevertheless, that I have tried to be useful by formulating, as carefully as I could, my vision of beings and of things."

Despiau was sipping a little glass of old brandy like a connoisseur.

"I will remember the address of this restaurant," he said.

"Upon my word," I said to him, "I would gladly take lodgings here if the master Rodin would come here every day to talk with his pupils."

A moment later Rodin resumed: "If I have insisted on our usefulness and if I still insist on it, it is because, by itself, this idea can restore to us the understanding we deserve in the world where we live.

"Today people are only concerned with profit. I would like this practical society to be convinced that it has at least as much interest in honoring artists as in honoring manufacturers and engineers."

Notes

Introduction

1. For example: "At every line we find this desire to parade, to spout general ideas about art, about artists, to prophetize, in a word to dogmatize, whereas one really feels, thank God, that the true inspiration of Rodin is entirely natural and entirely spontaneous" (G. de Pawlowski, "La Semaine littéraire." *Comœdia*, July 16, 1911).

2. When the book was published, few critics really noticed Gsell's participation; if they did, they praised him for the skill he showed in his interviewing technique. One of the rare critics—and not an unimportant one—who distinguishes Gsell from Rodin is Pierre Lasserre. In one of the few reviews that aim at the substance of their ideas, Lasserre observes, "M. Paul Gsell [is] one of our best critics. The collaboration of the great sculptor and this connoisseur with a mind as fine and precise as it is sensitive to beauty has produced a superior book, full of thought and charm . . . entirely comparable with the *Conversations of Goethe with Eckermann*. Not only the framework and the form of the composition are the same, but there is a veritable resemblance in the tone and the substance. Goethe would have loved this book. He would have recognized here many of his own ideas." Nonetheless, in conclusion, Lasserre notices Gsell's political intentions: "This beautiful and abundant book . . . I like very much, with the exception of one page, the last, where M. Paul Gsell makes a declaration of revolutionary individualism, quite surprising on the part of this friend of the Muses, of this observer" ("Chronique des lettres: Les idées de Rodin," *L'Action Française*, July 23, 1911). Against the general tendency to disregard Gsell, L. de Lutèce credits him as the real author and, moreover, criticizes him for distorting Rodin's image ("L'Art," *Le Journal des Arts*, January 7, 1914).

Most of the articles published in the periodical press present excerpts from one or several chapters that elucidate Rodin's work

rather than the nature of his thought. See H. C., "Autour de Fran-
çois Rude et de Auguste Rodin," *Le Bien Public* (Dijon), June 27,
1911; Gabriel Mourey, "Les Entretiens de Rodin," *L'Opinion*, July
8, 1911; G. de Pawlowski, "A. Rodin: L'art," *Comœdia*, July 16,
1911; André Chaumeix, "Le Mouvement des idées," *La Revue Heb-
domadaire*, August 5, 1911, pp. 109–28; Gustave Kahn, "Art mo-
derne," *Mercure de France*, September 1, 1911, pp. 188–91; Henri
Roché, "Le Sculpteur Rodin et le corps humain," *Paris Médical*, Sep-
tember 30, 1911; Pierron, "Les Arts: Propos d'Auguste Rodin,"
Revue d'Europe et d'Amérique, October 15, 1911, pp. 709–13; Daniel
d'Arthez, "M. Rodin et la philosophie de l'art," *Le Petit Phare*
(Nantes), October 28, 1911; Fagus, "Un Livre de raison," *La Revue
Critique*, November 10, 1911, pp. 354–64; Phylax, "L'Esthétique
de M. Auguste Rodin," *La Libre Parole*, January 31, 1912; Charles
Maurras, "La Doctrine officielle de l'université," *L'Action Fran-
çaise*, November 26, 1912; Joseph Desaymard, "L'Influence d'Henri
Bergson," *Le Siècle*, December 9, 1912; "La Cinématographie: Son
rôle dans les études biologiques," *La Presse Médicale*, April 23, 1913.
3. The question of Rodin's writings has been evoked in some detail
by one of his secretaries, who alleges that the sculptor's will stipu-
lates that the first director of the Musée Rodin, Léonce Bénédite,
"sort out and publish his writings and correspondence" (Marcelle
Tirel, *Rodin Intime* [Paris: Editions du Monde Nouveau, 1923], p.
16). Tirel is one of the few contemporaries of Rodin to emphasize
his persistence in noting his thoughts, his exact ideas, especially his
punctuation, and to discuss his relationships with those many peo-
ple who transcribed his notes and his doubts about the value of the
transcriptions. Tirel especially emphasized the collaboration be-
tween Rodin and Charles Morice for the publication of *The Cathe-
drals of France*. Some of Rodin's opinons that she quotes deserve to
be remembered: "It is difficult to make a book. . . . People do not
understand my explanations. Charles Morice read me a chapter
from *The Cathedrals*, I did not understand anything. He makes me
lie at every instant. . . . People always rewrite me. I only want these
gentlemen to correct my misspellings, but they change my ideas."
Thinking, perhaps of Rodin and Gsell's book, Tirel concludes:
"Many serious people have read, without laughing, his admirable
Thoughts about art, flowers, the sky, the atmosphere. . . . Pre-
sented to the public, after having passed through so many hands,

what seemed to have had value, in reality is as imprecise as something from long ago that the centuries have blurred. But it is only a very clever camouflage, well assembled, well constructed. I have, before my eyes, traced in pencil, poorly formed, the crude words, the incomplete sentences of an unpublished fragment of these *Thoughts* written on the pitiful letter of a model soliciting posing sessions. Here is a sample in which I have respected the spelling" (p. 104).

4. Several chapters were excerpted at the same time by newspapers and periodicals, e.g., "Pensieri di Rodin," *Nuova Antologia*, May 1, 1910; "I Busti di Rodin," ibid., August 15, 1910; "Disegno et colore," ibid., January 1, 1910; "Le Réalisme dans l'art: Propos d'Auguste Rodin," *La Gazette de Lausanne*, March 12, 1910; "La Beauté de la femme, par A. Rodin," *Le Matin*, May 1, 1910. Some of these articles were published anonymously; others were signed by Rodin and Gsell.

5. "Auguste Rodin raconté par lui-même," *La Revue*, May 1, 1906; "Propos d'Auguste Rodin sur l'art et les artistes," ibid., November 1, 1907, repeated in substance in P. Gsell, "Chez Rodin," *L'Art et les Artistes* (1914).

6. *Promenades dans nos musées* (Paris: Librairie May, 1899); "Les Entretiens d'Anatole France," *La Grande Revue*, June 25, 1909, pp. 756–77.

7. To limit ourselves here to sculptors, one of the inquiries carried out at *La Revue* by E. Melchoir de Vogüe tells us Rodin's, Dalou's, and Bartholdi's opinions on "What Scientists, Writers, and Artists Drink." Rodin declares, "I believe that wine is an excellent thing. If people drink so little, and if it has even become fashionable to drink none, I believe for my part that this is simply because it has too often been adulterated" (*La Revue*, January 1, 1908, p. 12).

8. "A propos du Salon de la Société Nationale des Beaux-Arts: La faillite du nationalisme dans les beaux-arts," *La Revue*, May 1, 1904, pp. 37–41; "La Vérité sur l'impressionisme," ibid., October 15, 1907, pp. 492–504; "Faux et faussaires artistiques," ibid., July 15, 1907, pp. 246–57; "La Faillite des salons de peinture," ibid., June 1, 1908, pp. 306–25; "L'Enlaidissement de Paris," ibid., May 15, 1908, pp. 191–207.

9. "It was then useful to denounce the formidable racket organized by some critics and some merchants on the subject of a trio of daub-

ers. It was necessary to isolate from this ridiculous group that which the glorious Impressionist School has produced and is still producing" ("La Vérité sur l'impressionnisme," *La Revue*, October 15, 1907, p. 504).

10. *L'U.R.S.S. et sa foi nouvelle* (Paris: Edition des Portiques, 1934); *Le Monde à l'endroit, U.R.S.S.* (Paris: Editions Sociales Internationales, 1936); *Le Théâtre soviétique* (Paris: Editions Sociales Internationales, 1937).

11. In 1911, the city of Paris voted to purchase 115 copies of *Art* and to give them to the popular libraries, "30 to pedagogical libraries, 60 to communal libraries, 16 to free public libraries, 1 to the General Council of the Department of the Seine, 2 to the Ecoles Normales d'Institutrices" (*Bulletin municipal officiel, Hôtel de Ville de Paris*, July 9, 1911).

12. "Sir, *La Revue des Revues* organizes at this time and will publish in the near future a survey of the most eminent personalities of the different countries of Europe on the question of whether patriotism is incompatible with the humanitarian feelings that are developing today in all the civilized world. We have already received, among other replies, those of MM. Anatole France, Alfred Fouillée, François Coppée, Paul Déroulède, Faguet, Sully Prudhomme, Mézières, Jules Claretie, Elisée Reclus, Octave Mirbeau, P. et V. Margueritte, Gabriel Monod, Ferdinand Buisson, Frédéric Passy, d'Estournelles de Constant, Momsen who sent us his opinion a few days before his death, Lord Avebury, de Gubernatis, Maeterlinck. We are taking the respectful liberty of addressing ourselves particularly to you, and we would be infinitely happy to obtain the support of your magisterial, artistic authority to enlighten public opinion on a question of such great social importance. Yours truly . . . December 10, 1903."

The question attached to the letter reads as follows: "Patriotism, is it incompatible with the humanitarian feelings that seem to assert themselves more and more in the civilized world: solidarity among all members of humanity; consciousness of the savagery of the primitive instincts that make different races hate each other; horror of the fight in which men kill each other even though they would have personally had, in most cases, every reason to esteem each other; respect for justice recognized as superior to brute force for resolving conflicts between nations, as well as debates between in-

dividuals? Have we arrived at a time when the idea of nation, having borne all of its fruits for the development of humanity, would tend to be replaced by other ideas? Or else, on the contrary, is it good that each nation preserves its patriotism to continue its historical evolution and to work in its own way for the progress of humanity?" (Paul Gsell File, Musée Rodin, Paris, Archives). On December 14, 1903, Gsell wrote: "Dear Master, Here is the writing of the opinions that you were kind enough to communicate to me yesterday on the question of our inquiry. I have endeavored to respect the meaning and to keep the measure you recommended. Since all our correspondents were kind enough to answer us in writing, we would be infinitely grateful if you would sign this text after you have added any modifications you think necessary. The reader is only interested, in fact, in testimonies whose authenticity is guaranteed."

The following text is attached to the letter: "It seems to me that, today, nations are only groups of material interests. As far as the soul of nations, their special culture, this no longer exists: it is at least the finding that I am forced to make in my artistic sphere. If it is true that the specific spirit of a people is shown in its art, since there is no longer a national art, one must conclude that there is no longer any national individualism. In our time there has been a fusion of all national souls in nothingness. Formerly, there existed a French spirit that manifested itself in our artistic school, but now it has ceased to be; and if the foreigners still run to us to ask for lessons in taste, this is because we still hold for them an old renown which we no longer merit. In reality, there is no longer any common thought, common art, with us or with others: the heart and the art of nations are dead. No doubt there are still personalities with talent, and it is quite possible that there are more in France now than elsewhere; but they are isolated, they are not grouped into national schools. Financial life, material life, has taken the place of moral and intellectual life everywhere. Today when a country accumulates weapons, this is not to defend its patrimony of thoughts, of art, of spiritual customs from neighboring countries, but it is to safeguard utilitarian advantages that it was able to acquire in the world. These advantages, in fact, are not despicable, and it is completely useless to give them up for the advantages of other people. This is why it would seem to me imprudent under the pretext of humanitarian generosity to make way for other nations and, for example, to dis-

arm when they do not appear to have the same intention" (Paul Gsell File, Muśee Rodin, Paris, Archives).

On December 22, 1903, Gsell wrote to Rodin: "I took the liberty of sending you the text of the very interesting conversation I had with you. I am afraid that you did not receive it, and I am sending it to you again. Will you allow me to *sign it with your name* so that it can be placed among the signed answers submitted on this question by the most illustrious personalities of Europe, among others, Anatole France, Emile Faguet, François Coppée, Jules Claretie, Octave Mirbeau, Mézières, Frédéric Passy, Elisée Reclus, Président Magnant, Paul Deschanel, Paul Déroulède, Momsen, Haeckel, Max Nordau, Maeterlinck, Vandervelde [*sic*], Lord Avebury, Ferreco, de Gubernatis. We would be infinitely happy to publish the opinion of a master such as you. On the other hand, I do not want to inconvenience you, and if you do not have any objection to its publication you do not need to reply" (Paul Gsell File, Muśee Rodin, Paris, Archives).

13. " 'Without any doubt,' Rodin told me, 'Van Gogh is very uneven. But one must recognize in him a quality that is very rare today and even more precious: sincerity. His is comparable to that of the primitives. . . . He neglects all academic recipes; he ignores the method of making up a painting as if it were a dish or a sauce according to the directions of a cookbook. He places himself naively before Nature and tries to translate it. Whether he succeeds perfectly, this is another story. It is certain that he does not know how to draw. It is a defect common to several Impressionists. The massiveness of this portrait is evidently regrettable. I, who like so much to express in my works the logic and harmony of natural lines, am shocked by this heaviness. But in my hatred of everything that smells of the *Ecole*, I readily pardon Van Gogh's independence. . . .' Finally I wanted to have his opinion on the most excessive of these, on the one whose asymmetrical portraits and zigzagging still-lifes the new criticism admires on its knees, on Cézanne. When he heard this name, Rodin slightly raised his shoulders very softly, as if excusing himself: 'This one I do not understand!' " ("Propos d'Auguste Rodin sur l'art et les artistes," *La Revue*, May 1, 1906, pp. 95–107).

14. "Dear Master, I will come Saturday morning at 8:30 to assist you with your correspondence. Your respectfully devoted, P.

Gsell," May 19, 1910 (Paul Gsell File, Muśee Rodin, Paris, Archives).

15. "La Beauté de Paris," *La Revue*, July–August 1911, pp. 165–68.

16. "En haut de la colline" and "Chez Rodin," *Rodin: L'homme et l'oeuvre*, special issue of *L'Art et les Artistes*, 1914, pp. 13–28, 49–72.

17. "Auguste Rodin," *La Revue de Paris*, January 15, 1918, pp. 400–17; "Naissance d'une vocation: Les premières années de Rodin," *Le Livre et Ses Amis*, no. 2, 1946; "Rodin et la guerre," *Pro arte*, vol. 3, 1924.

18. "Anatole France déjeune chez Rodin," *La Revue Hebdomadaire*, October 29, 1921, pp. 608–16; *Propos d'Anatole France: Recueillis par Paul Gsell* (Paris: Bernard Grasset, 1921).

19. Letters and telegrams from Gsell to Rodin, January 20, May 19, August 31, 1910, Musée Rodin, Paris, Archives.

20. The archives of the Musée Rodin in Paris preserve, besides notebooks, a large collection of notes dictated by Rodin, typewritten, and occasionally annotated by his hand. They are presently being inventoried. One example of a writing by Rodin bearing numerous annotations on the typewritten copy is preserved at the Fondation Custodia, Institut Néerlandais, Paris. It is an "appendix" to the *Venus de Milo*, eight pages annotated by Armand Dayot, who says: "These proofs have been retouched by Rodin himself in front of me. All the additions in pen and pencil are by his hand."

Preface

1. In 1900, at the same time as the Paris World's Fair, Rodin held a one-man exhibition of his drawings and sculpture. For this purpose, he had a special pavilion constructed at the Pont de l'Alma. It was later removed and reerected on the grounds of his home at Meudon.

2. Since his account was published in 1911, Gsell implies that Rodin moved to Meudon around 1890 or earlier. However, this information conflicts with accounts by Rodin's biographers, who date the move somewhat later. Judith Cladel, who knew Rodin in the 1890s, says that he moved into the Villa des Brillants in 1897 (*Rodin: Sa vie glorieuse, sa vie inconnue* [Paris: Bernard Grasset, 1950], p. 248). Frederick Lawton, who knew Rodin a few years later, gives 1894 as

the date that this house was purchased (*The Life and Work of Auguste Rodin* [London: T. Fischer Unwin, 1906], p. 124).

3. Rodin's avid collecting of Greek and Roman, as well as Egyptian, medieval, Asian, and contemporary European, art is well known. See Museé Rodin, *Rodin collectionneur* (Paris: Les Presses Artistiques, 1967–1968).

4. Molière, *Le Tartuffe*, 3.2.861–62.

Realism in Art

1. Rodin's *Gates of Hell* was not cast in bronze during his lifetime, so at the time of this interview it existed only in the incomplete plaster state.

2. Gsell refers to the work usually known as *The Prodigal Son*.

For the Artist Everything in Nature Is Beautiful

1. François Villon, "The Testament," in *The Poems of François Villon*, trans. Galway Kinnell (Boston: Houghton Mifflin, 1977), p. 55, lines 457–60.

2. Ibid., p. 57, lines 487–94, 501–03; p. 59, lines 504–05, 517–24.

3. The Musée du Luxembourg was inaugurated in 1818 and existed until 1937. It was designated for the display of works of art purchased by the French government from living artists.

4. Charles Baudelaire, "Une Charogne," in his *Les Fleurs du mal*, XXIX.

Movement in Art

1. This is an allusion to the final scene in Molière's *Dom Juan ou le festin de Pierre* in which the statue of the Commander comes to life.

Drawing and Color

1. The South Kensington Museum changed its name to the Victoria and Albert Museum in 1899.
2. In this dichotomy between color and drawing, Gsell refers to a long-standing controversy in Western painting dating back to the Renaissance.

The Beauty of Woman

1. The Hôtel de Biron is the present location of the Musée Rodin in Paris.
2. The Dépôt des Marbres, which no longer exists, was a studio-storage complex provided by the French government for artists who were working on government commissions.
3. Rodin refers to Goujon's well-known reliefs for the Fountain of the Innocents still *in situ* in Paris.
4. Rodin observed and drew a traveling troupe of Cambodian dancers in Paris, then in Marseilles, in 1906.
5. Hanako is the nickname for the Japanese actress Ohta Hisa (1868–1945). We know that Rodin made studies of her face and figure as early as 1907 and completed at least eight portraits.
6. Victor Hugo, "Le Sacre de la femme," in his *La Légende des siècles*, II, lines 146–56.

Souls of Yesterday, Souls of Today

1. Although he is little known today, Jean-Jacques Henner (1829–1905) was held in high repute in the late nineteenth century.
2. In Rodin's lifetime, the study of physiognomy was popularly regarded as a guide to character. Considered a pseudo-science today, the systematic study of physiognomy was initiated in the eighteenth century by Johann Caspar Lavater. An earlier artistic tradition in which facial types were related to animals also informs Rodin's discussion of Houdon's busts.
3. Duc (Louis) de Saint-Simon (1675–1755) is noted for his perceptive memoirs.

4. Aimé-Jules Dalou (1838–1902), a sculptor of great repute in the late nineteenth century, was a competitor of Rodin.

5. Dalou was active in the Paris Commune of 1871 and was forced into exile afterwards. He returned from England in 1880.

6. Charles Le Brun (1619–1690), as *premier peintre* to Louis XIV and director of the Académie Royale, exerted great influence on the artists of his time.

7. When exhibited at the Salon of 1898, Rodin's *Balzac* was rejected by the society, which had commissioned it in 1891, because it seemed unlifelike.

Thought in Art

1. Rodin is referring to his marble *Monument to Victor Hugo*, formerly in the garden of the Palais Royal. Today it is in the Musée Rodin collection.

2. Casts of this work are usually known as *The Faun and the Nymph* (the title used in the caption to the photograph in the original edition of *L'Art*) or *The Minotaur*.

Mystery in Art

1. Victor Hugo, "A Villequier," in his *Les Contemplations*, Book IV, lines 41–44.

2. Rodin's description of *The Gleaners* is not quite accurate. The figure on the right raises her back halfway and does not look at the horizon.

3. Victor Hugo, "Fantômes," in his *Les Orientales*, XXXIII, lines 19–30.

4. Gsell undoubtedly refers to the *Bust of Mme. Vicuña*.

Phidias and Michelangelo

1. The term *practitioner* refers to a sculptor who does the physically difficult initial part of carving.

2. Rodin uses the French equivalent of the anatomical term *malleolus internus*.

3. Rodin is speaking of his first trip to Italy in 1875.

4. "So potent was Superstition in persuading to evil deeds" (*De rerum natura*, trans. W. H. D. Rouse [Cambridge, Mass.: Loeb, 1975], I:101).

5. Rodin wrote a poetic essay on the Venus de Milo, which was published as "Venus," in *L'Art et les Artistes* 11 (March 1910): 243–55.

6. Rodin alludes to a well-known image in Delacroix's *Liberty on the Barricade* (1830).

The Usefulness of Artists

1. This was one of several annual exhibitions held in Paris around the turn of the century.

Select Bibliography

Writings on Rodin

The following selected titles will give readers further information on Rodin's life and on important works discussed in *Art*.

Bénédite, Léonce, *Rodin*. London: Ernest Benn, 1924. An early and still-valuable survey of Rodin's *oeuvre* with excellent photographs.

Caso, Jacques de, and Patricia B. Sanders. *Rodin's Sculpture: A Critical Study of the Spreckels Collection, California Palace of the Legion of Honor*. San Francisco: Fine Arts Museums of San Francisco, 1977. A thorough study of a major Rodin collection in the United States with interpretive essays on many of his most important sculptures.

Cladel, Judith. *Rodin: Sa vie glorieuse, sa vie inconnue*. Definitive Edition. Paris: Bernard Grasset, 1950. Still the most detailed and comprehensive biography of Rodin, written by a close associate.

Elsen, Albert E. *Rodin's Gates of Hell*. Minneapolis: University of Minnesota Press, 1960. An in-depth study of a major work.

———— . *Rodin*. New York: Museum of Modern Art, 1963. The first modern reassessment of Rodin's art in English, published on the occasion of the 1963 Rodin exhibition at the Museum of Modern Art.

Elsen, Albert E., ed. *Rodin Rediscovered*. Washington, D.C.: National Gallery of Art, 1981. A valuable collection of essays published at the time of the major Rodin exhibition of the same name at the National Gallery.

Grappe, Georges. *Catalogue du Musée Rodin, I: Hôtel Biron—Essai de classement chronologique des oeuvres d'Auguste Rodin*. 5th ed. Paris, 1944. A schematic, but still the only comprehensive, catalogue of the Musée Rodin in Paris.

Lawton, Frederick. *The Life and Work of Auguste Rodin*. London: T.

Fischer Unwin, 1906. An early and excellent biography, which does not, however, cover the last years of Rodin's life.

Rilke, Rainer Maria. *Rodin*. Translated by Robert Firmage. Salt Lake City: Peregrine Smith, 1979. Contains two important essays of 1903 and 1907.

Tancock, John L. *The Sculpture of Auguste Rodin: The Collection of the Rodin Museum of Philadelphia*. Philadelphia: David R. Godine and the Philadelphia Museum of Art, 1976. A catalogue with valuable information on versions and variants of the many pieces in this important collection.

Writings and Statements by Rodin

Most of Rodin's writings have never been assembled, translated, or critically evaluated. At the present time, the Musée Rodin is engaged in a project to publish the correspondence in their archives. In collaboration with the Musée Rodin, we are preparing the publication of Rodin documents kept in archives and collections outside France.

Cladel, Judith. *Rodin: The Man and His Art, with Leaves from His Notebook*. New York: Century, 1917. Includes an often-overlooked section with numerous quotations from Rodin's writings.

Dujardin-Beaumetz, Henri-Charles-Etienne. *Entretiens avec Rodin*. Paris: Editions Dupont, 1913. Translated and republished in Albert E. Elsen, ed., *Auguste Rodin: Readings on His Life and Work*. Englewood Cliffs, N.J.: Prentice-Hall, 1965. Interviews by an official of the Fine Arts Administration of France and a supporter of the artist. Covers many of the same topics found in *Art*.

Rodin, Auguste. *To the Venus of Milo*. Translated by Dorothy Dudley. New York: Huebsch, 1912. First published in 1910 as a poetic tribute to a favored antique statue.

――――. *The Cathedrals of France*. Translated by Elisabeth Chase Geissbuhler. 1914. Rev. ed., Redding Ridge, Conn.: Black Swan Books, 1981. Contains extensive commentary on Gothic architecture and other topics. Produced in collaboration with the Symbolist poet Charles Morice.

Index

Compositor:	Wilsted & Taylor
Printer:	Thomson-Shore, Inc.
Binder:	John H. Dekker and Sons
Text:	Bembo
Display:	Bembo

Plates

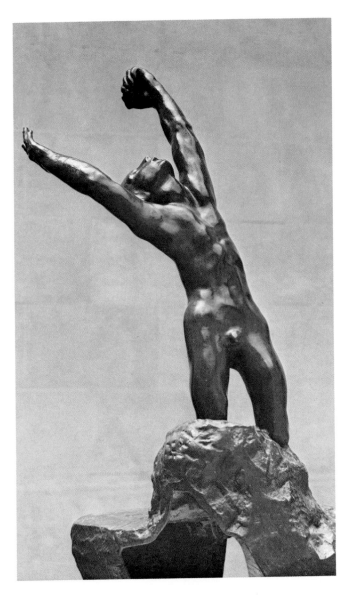

1. Rodin, *The Prodigal Son*, ca. 1887, bronze.

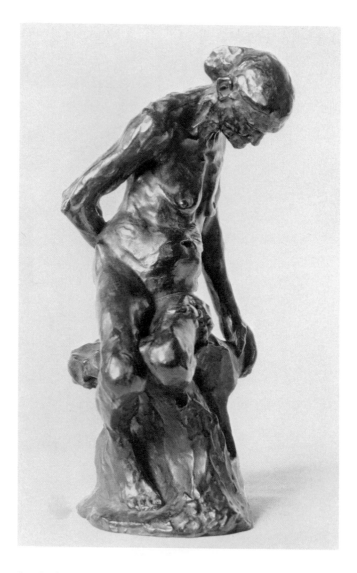

2. Rodin, *The Old Courtesan*, early 1880s, bronze.

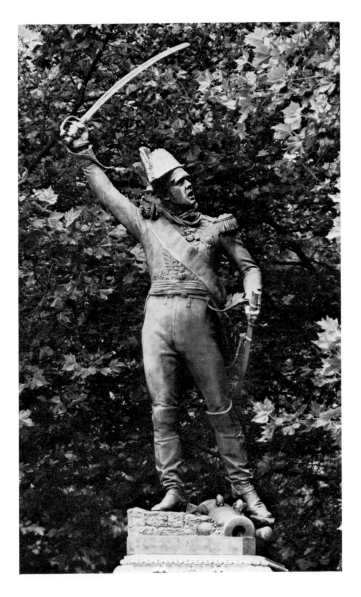

3. Rude, *Maréchal Ney*, 1852–1853, bronze.

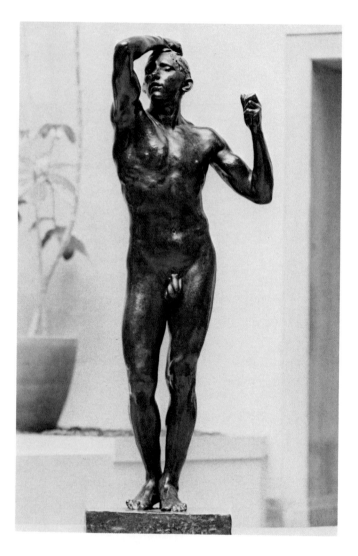

4. Rodin, *The Age of Bronze*, 1875–1877, bronze.

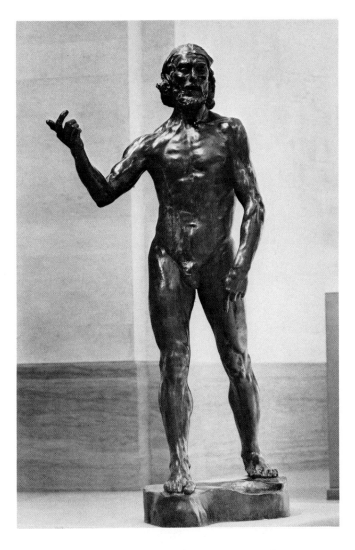

5. Rodin, *Saint John the Baptist Preaching*, 1878–1880, bronze.

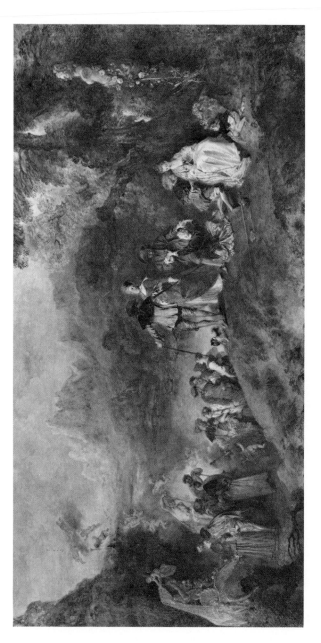

6. Watteau, *The Embarcation for Cythera*, 1717 (detail).

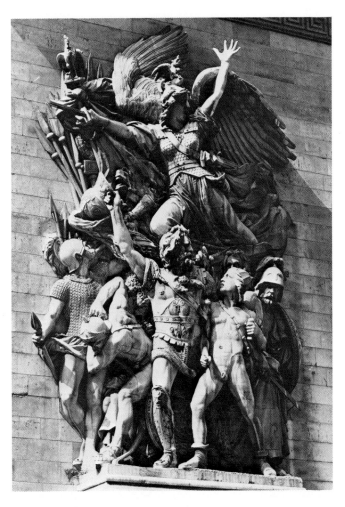

7. Rude, *La Marseillaise*, 1833–1836, stone.

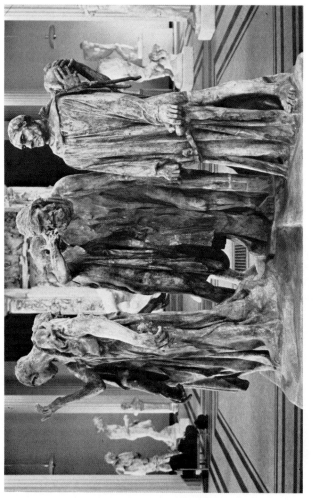

8. Rodin, *The Burghers of Calais*, 1884–1895, plaster.

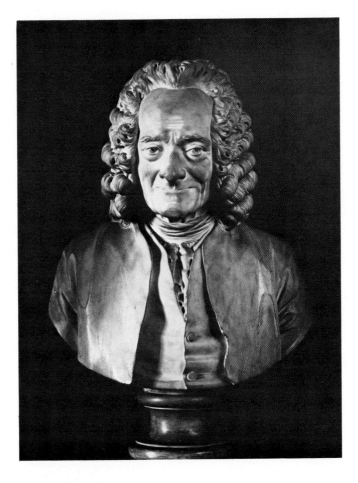

9. Houdon, *Bust of Voltaire*, 1778, marble.

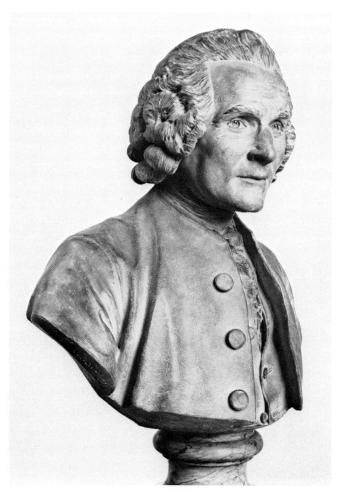

10. Houdon, *Bust of Rousseau*, 1778, terracotta.

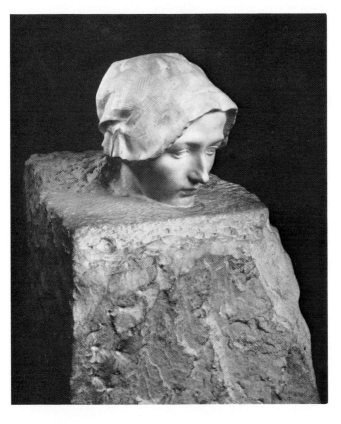

11. Rodin, *Thought*, 1886–1889, marble.

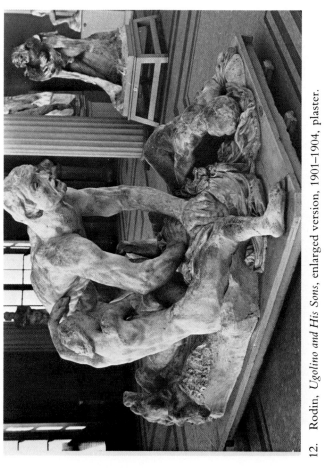

12. Rodin, *Ugolino and His Sons*, enlarged version, 1901–1904, plaster.

13. Rodin, *The Centauress*, 1887–1889, plaster.

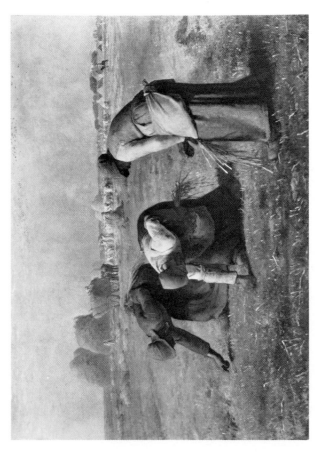

14. Millet, *The Gleaners*, 1857.

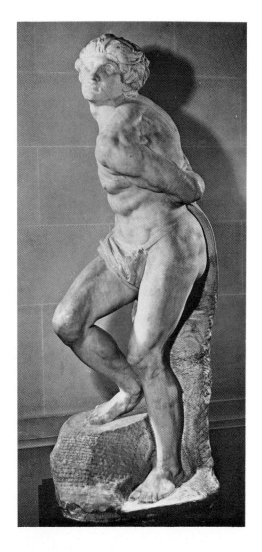

15. Michelangelo, *The Slave*, ca. 1513, marble.

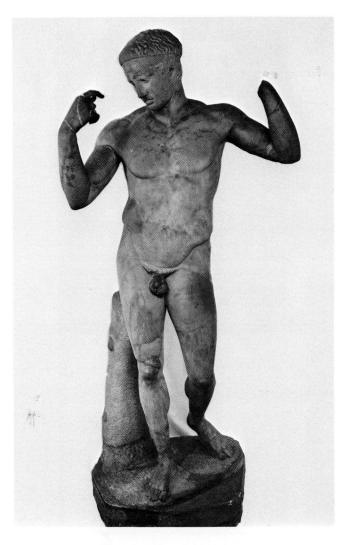

16. *Diadoumenos*, marble copy of a bronze original by Polyklei-
tos, ca. 420 B.C.